Painting With PASTELS

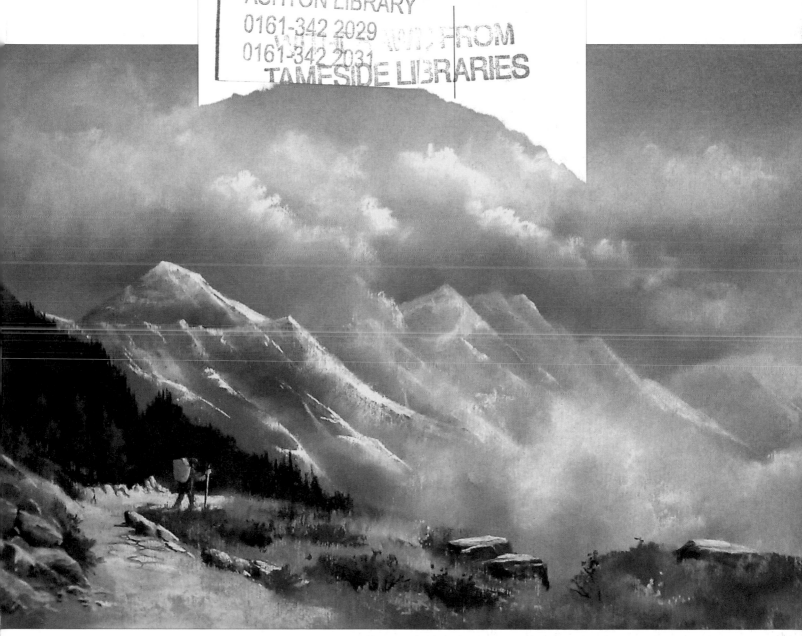

To my daughters, Joanne and Caroline, who share my love of
the countryside and travel.

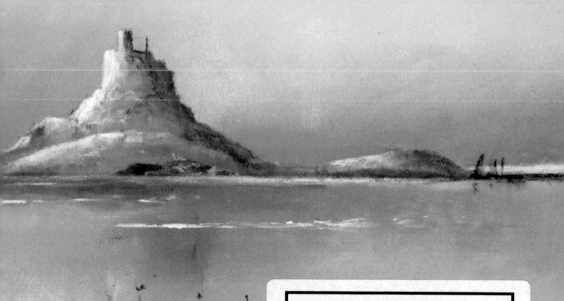

Painting With
PASTELS

Jenny Keal

First published in Great Britain 2011

Search Press Limited
Wellwood, North Farm Road,
Tunbridge Wells, Kent TN2 3DR

Reprinted 2011, 2012, 2013

Text copyright © Jenny Keal 2011

Photographs by Paul Bricknell, Search Press Studios

Photographs and design copyright © Search Press Ltd. 2011

ISBN 978 1 84448 590 1

The Publishers and author can accept no responsibility for any consequences arising from the information, advice or instructions given in this publication.

Suppliers
If you have difficulty in obtaining any of the materials and equipment mentioned in this book, please visit the Search Press website for details of suppliers: www.searchpress.com

Publishers' note

All the step-by-step photographs in this book feature the author, Jenny Keal, demonstrating how to paint with pastels. No models have been used.

Printed in Malaysia

Acknowledgements

I would like to thank David Bellamy for his support and encouragement and Roz Dace, Sophie Kersey and the team at Search Press who have helped me throughout every stage of producing this book.

Cover:
Little Langdale, Cumbria
54 x 32cm (21¼ x 12⅝in)

Old buildings in wild and remote landscapes provide the inspiration for many of my paintings. It is not just their picturesque quality but the almost palpable sense of the past they evoke: the nostalgic view we have of our rural heritage and perhaps the longing for a simpler way of life. Every stone seems to tell a story.

Page 1:
Everest
35 x 19cm (13¾ x 7½in)

One of the most rewarding moments of my life was our first sight of Mount Everest on our Himalayan trek. We had to rise at 5.00 a.m. to climb to this viewpoint because by 9.00 a.m. the mountain was obscured by cloud. The water froze on my watercolour sketch, creating delightful patterns. The thrill of that view made every gruelling step of the climb up the Khumbu Valley worthwhile. I used the cloud to simplify the mass of detail on the slopes of the mountain.

Pages 2–3:
Lindisfarne
34 x 24cm (13⅜ x 9½in)

This painting also appears on page 58.

Left:
Oriental Poppies
22 x 22cm (8⅝ x 8⅝in)

When the first of these dynamic flowers opens in my garden, it never fails to thrill me. The flamboyance of the colour and energetic size of the blooms cannot be ignored.

Opposite:
Irish Cottage
33 x 15cm (13 x 6in)

In the west of Ireland, these old buildings still survive in remote locations. Vernacular architecture set in wild landscapes is my preferred subject for sketching and painting. I am inspired by a sense of timelessness and the history of the people who populated these isolated communities.

CONTENTS

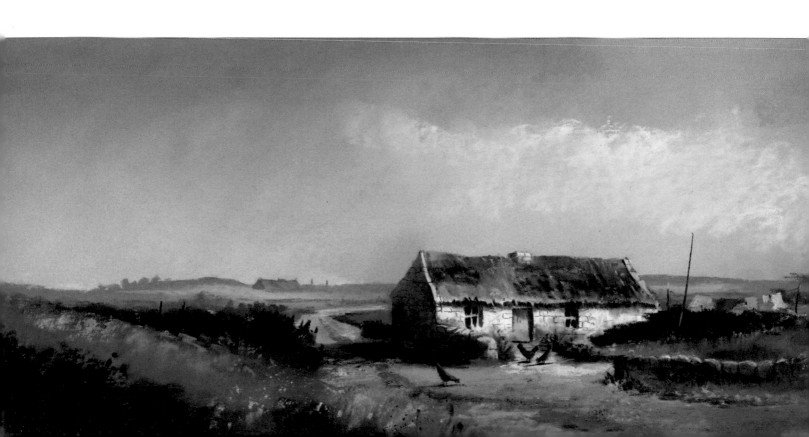

INTRODUCTION

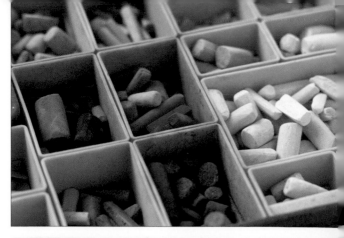

How often do we hear someone say 'I wish I could paint, but I don't have the talent'? Painting is most certainly a skill that can be learned, and with some practice, just as if you were starting to play a musical instrument, progress can be rapid. Pastel is the ideal medium in which to start to paint and to develop your skills. Perhaps you have been painting for some time in other media but are dissatisfied with your work. A change to pastel might well be the answer.

We all need an outlet for our creativity, and pastel, being such an expressive and immediate medium, allows us to paint quickly, with enthusiasm and vigour.

Perhaps the time you have available to paint is limited. If so, painting in pastel could be a solution. A pastel painting can be finished in one session with no delays waiting for watercolour washes or a stage of an oil painting to dry.

The advantages of pastel are numerous. It is the most direct form of painting: holding the colour between your fingers, you are literally touching the painting, using your fingers to blend and soften the colour, just like the finger painting we did as children. This method of painting, with your hands directly in touch with the medium, was almost certainly the first form of visual art as evidenced by the prehistoric cave paintings and rock art from all around the globe. This physical connection with your work can have a profound effect on the emotional content of your paintings.

With pastel, the colours appear more vibrant, because no additives or dilutants are used. Unlike watercolour, light colours can be painted over dark ones. Creating atmosphere is easier with pastel than with many other media, and with the addition of a few tools, forming hard and soft edges and fine detail becomes straightforward.

I will concede there are some disadvantages: the main problems being dust and the vulnerability of the finished work. However, in this book I will explain how to overcome these issues with methods of dust control, keeping your hands and work space clean. I will also show you how to protect your finished work.

Pastel transformed my painting. For years I had been struggling with watercolour and the day a friend generously loaned me his box of pastels marked a turning point in my art that ultimately led to my becoming a full-time artist.

Whether you are just starting to paint or have been painting in other media for a while, I urge you to try painting with pastel. I am confident you will be pleased with the results right from the start.

St Catherine's Castle, Fowey

34 x 24cm (13³/₈ x 9½in)

Pastel is an excellent medium for depicting dramatic skies and sunsets. You can slap in as much colour as you like and if it seems too exuberant, you can always soften the colours together to subdue the more violent hues. This often results in a satisfying and realistic effect.

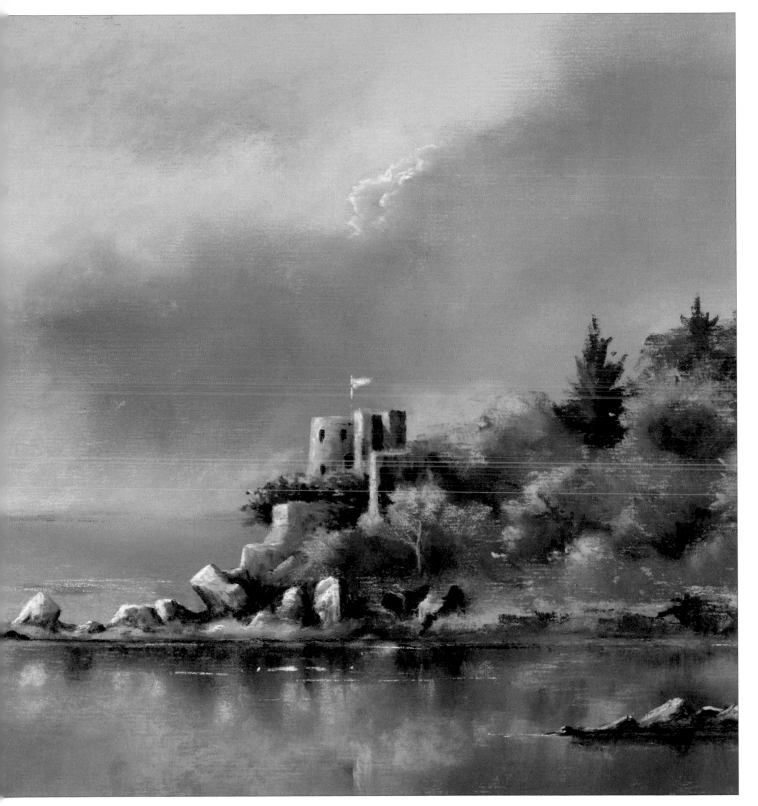

MATERIALS

PASTELS

There are three types of pastel – soft pastel, hard pastel and oil pastel. The subject of this book is soft pastel although occasionally hard pastel can be combined with soft pastel for certain effects. The predominant characteristics of soft pastel are its ease of application and capacity for blending, therefore it is important to choose a good quality brand of pastel. Some pastels advertised as 'soft' are actually quite hard and therefore not so readily blended. If you can test the pastel before you buy, a good rule of thumb is that the colour should come off on your finger when you pick up the stick. If it does not, then the pastel is hard. Another important feature to look out for is a wide colour range. Many of the cheaper brands of pastel have a limited range of colours and very few grey tints, which are vital for painting landscapes.

Unlike other media, mixing two colours in pastel will not produce a third. For example, you cannot mix blue and yellow on the page to get green. The results will tend to be grey. Within each colour there will be four or five tones ranging from light to dark. Therefore you need to buy a number of colours and tones. However, the advantage is that you do not have to learn how to mix colours and having the pastels in their various shades laid out before you helps you to understand the relationship between colour and tone.

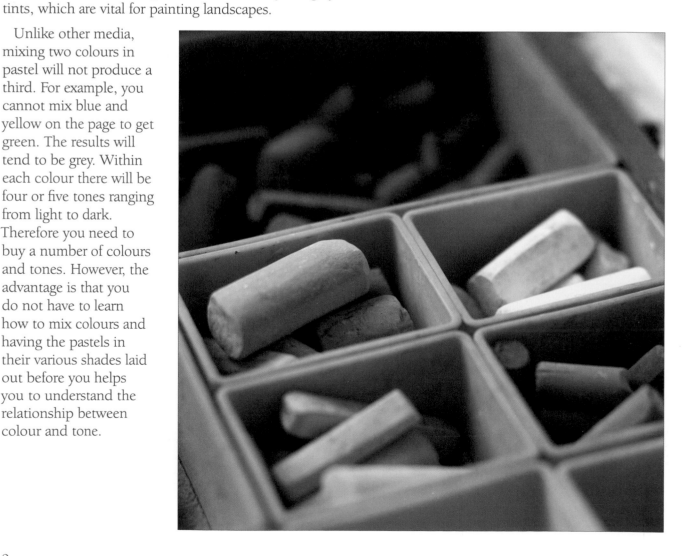

PASTEL PENCILS

Attempting to draw fine detail with a shapeless stick of pastel is unrewarding but with the addition of a few pastel pencils, sharpened to a fine point, you can produce plenty of high definition detail. Once again it is important to find a pastel pencil with the right consistency: too soft and you cannot sharpen them to a fine point, or too hard and they will not release their colour over the pastel already on the painting. Pastel pencils that are soft enough will make a mark on your finger, but finding a brand that will sharpen to a fine point is more difficult as you can hardly take out your craft knife in the shop and start hacking away at the pencils. The best clue is if they are presented with a point already or are cut fairly short with a blunt end in the display.

HARD PASTELS

Hard pastels on their own are most often used for drawing in colour, leaving large areas of paper showing. For the style of pastel painting described in this book, they are useful for creating sharp edges and detail. A hard pastel is less likely to break if you apply pressure to it when drawing into your work. The edges stay sharper, giving a cleaner mark than a soft pastel. A combination of soft pastels for the broader passages and hard pastel for detail is very effective. I have only used a hard pastel once in the demonstrations in this book: for creating ripples in the water in the *Harbour Scene* demonstration that begins on page 60.

SURFACES

Pastel can be painted on to a number of different surfaces. There are numerous tinted papers on the market with lovely subtle tones to complement your work. If you enjoy painting vignettes, i.e. gradually fading out the painting, leaving the margins unpainted, then these papers are an excellent choice, as the paper you leave untouched is a pleasing colour. It is also possible to paint pastel on to watercolour paper, especially if you enjoy using mixed media. However, avoid the very rough watercolour papers because the texture creates a mechanical, rash-like effect as the pastel is applied.

Many pastel painters prefer an abrasive painting surface, as the colours appear more intense, there is less dust, and the image is less vulnerable to scuffing. It is also possible to create finer detail on a fine sanded surface. In the past those of us who like to work on a sanded surface have had to rely on industrial sandpaper, but there are now several products on the market made specially for artists.

Tinted papers made specially for soft pastels.

With the introduction of Fisher 400 Artpaper, we can rest assured that our paintings will not deteriorate with age, since it imitates the qualities of the industrial product but is light-fast, archival and pH neutral. The other advantage of Fisher 400 is that it is waterproof, which means you can paint a watercolour or acrylic underpainting and add ink if you want to, making it excellent for mixed media.

You can also create your own abrasive surface using a pastel primer, which is an acrylic paste with fine abrasive particles that you can paint on to mount board or heavyweight paper. It comes in a range of colours and you can add water to vary the texture. This product is also available in sheet form. It is screen-printed on to sturdy backing paper in a range of tints.

The increasing popularity of pastel has meant that new painting surfaces are appearing on the market, and this creates new and exciting possibilities for the pastel artist.

Special sandpaper style art papers for use with soft pastels.

OTHER MATERIALS

With the addition of a number of simple tools, many of the perceived difficulties of pastel can be overcome.

Attach your paper or whatever surface you are working on to the board with masking tape. When the painting is finished, you can remove the tape to reveal a clean, neat edge.

Colour shapers allow you to manipulate the pastel once it has been applied. You can pick up colour and move it around; tidy up mistakes; straighten edges and refine detail. If colour shapers are used in conjunction with pastel pencils, there is no limit to the amount of definition you can achieve in pastel. I find the most useful shapers are the flat chisels in sizes 2 and 6, and I prefer the firm ones, as they keep their edge longer than the soft ones.

A palette knife is used to scrape pastel on to the painting whilst it is horizontal. You then use the flat of the blade to press it into the surface to create 'splatter'.

Charcoal pencil is recommended for the initial drawing of your painting as this will be absorbed into the pastel, unlike graphite which might show through. A sharp charcoal pencil is also useful for drawing detail.

I always sharpen my charcoal and pastel pencils with a craft knife, as this allows me to create a needle-sharp point, whereas a pencil sharpener can damage the fragile core of the pencil. A gentle touch and patience is needed to achieve a fine point.

You can remove large areas of pastel from a painting that you feel is going wrong, with a hog hair brush. Take the painting outside to do this, otherwise you will fill your studio with dust.

A soft-haired fan brush can be used if you wish to remove some of the pastel but not all of it. It can also be effective for suggesting grass or undergrowth by tickling the edge of a straight line of colour to break it up.

An old face flannel or microfibre cloth is essential to remove excess pastel from your hands as you work. As you blend colours together, you need to clean your hands so that colour from one area is not transferred to another.

I do not recommend spraying your final work with fixative, as it tends to dull the colours, but it can be used to spray a painting at an interim stage to seal it, so that further layers do not pick up the colour of the layer beneath.

Working upright on an easel (shown on page 15) will solve two of the most common difficulties when painting in pastel: dust and accidental scuffing of the image. It also allows you to step back away from the painting to check progress. If you work on a table with the painting at a 30 degree angle, you need to blow the excess pastel from the work, which propels pastel dust into the air. This is not only messy but also unhealthy. Working upright on an easel means that the excess pastel drifts down and virtually no blowing is necessary. In addition, a right-angled channel under your drawing board catches the pastel drift before it has time to circulate in the air. Using an easel also prevents accidental scuffing: you are less likely to smudge your masterpiece with your sleeve than if you were sitting at a desk and reached across the painting.

A sturdy drawing board (also shown on page 15) gives you a solid surface to work on and allows you to lie the painting flat for one of the techniques described later in this book.

Opposite

Clockwise from top left: masking tape, a face flannel, a craft knife, palette knives, a soft-haired brush, a soft-haired fan brush, colour shapers, a hog hair brush, charcoal pencils and a graphite pencil.

Fixative spray.

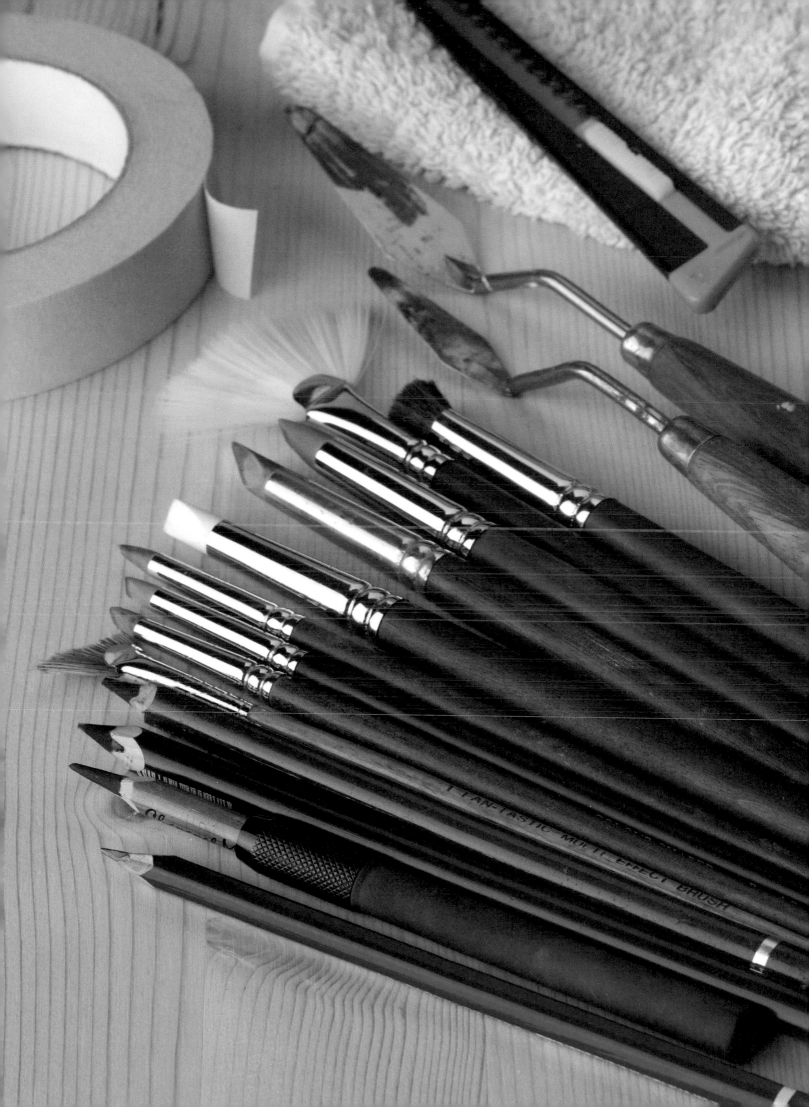

STUDIO SET-UP

The way you set up your painting area will have an important effect on your work. Obviously you want good light and space to spread out your equipment, but with pastel painting, the issue of pastel dust must also be taken into account, since this can be unhealthy as well as messy. There are a number of steps you can take to minimize the amount of dust you create (see opposite).

1. Always work upright on an easel, with a piece of right-angled channel under the drawing board. This allows the dust to drift down into the channel for disposal away from the working area.

2. Place a piece of absorbent fabric on the floor. An old towel is ideal. This not only protects your floor but catches any dropped pastels and prevents breakages.

3. Hold a dry, absorbent cloth in one hand as you work. This helps to keep your hands reasonably clean, and you can use it to clean any grubby pastels.

Working on an easel also allows you to step back from your work and view it from a distance, essential to check that the overall image is working. It is easy to miss an obvious mistake when you are close to the image.

My box for storing pastels in separate categories.

STORING PASTELS

If the pastel sticks are all stored in the same compartment, they will soon all look exactly the same sludge grey colour and you will never find the colour you want. A container that has a number of shallow compartments is ideal to separate the colours. You can buy purpose-built pastel storage units made from wood, but hardware or do-it-yourself stores have a range of plastic storage containers which fulfil the same purpose. You could also explore fishing shops as a good source of ingenious containers.

Sort the colours into categories, like warm or cool colours and tints from light to dark so that you can find what you want quickly. If, in spite of your precautions, your colours do become coated with grey dust, you can clean them by putting them into a container with some ground rice, giving them a quick shake and then separating them from the rice with a fine sieve.

With all the colours sorted, it is time to start painting. I find it useful to select the colours I need and either lay them out on an old towel or put them in a separate tray. This is to encourage me to stick to a limited palette.

PROTECTING PAINTINGS

Once the painting is finished, place it between a folded sheet of newspaper and store it flat in a drawer until you are ready to get it framed. These days, newsprint does not come off and you can safely leave your painting like this for a considerable time.

Framing behind glass is the only realistic answer for pastel paintings, and to prevent pastel from transferring to the inside of the glass, I ask for a double mount, which creates a space between the glass and the surface of the painting. For large paintings a triple mount can be used as the larger area of glass is more flexible and pastel can be imprinted on the inside of the glass if pressure is applied to the front and back of the framed painting. Therefore, the greater the space between the painting and the glass, the better.

My studio set-up, consisting of an easel with a right-angled channel, a board, a dry, absorbent cloth for my hands, my selection of colour shapers hanging below, a towel on the floor, and on a table my box of pastels and a towel to place them on.

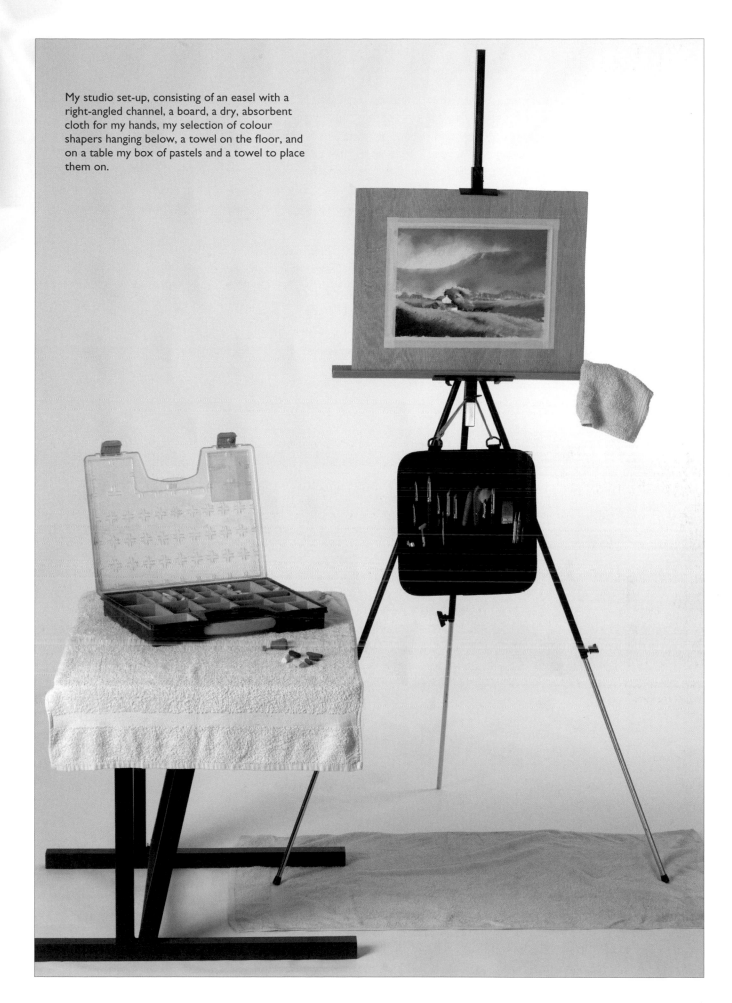

COLOUR THEORY

Colour theory sounds somewhat vague, but although this subject can be studied in great depth, the basic principle that warm colours advance and cool colours recede is all you need to know to get started in landscape or flower painting. In landscape painting in particular we aim to invite the viewer into the scene, and a sense of distance, or recession, as we call it, will encourage this feeling. Using cool colours in the distance and warm colours in the foreground is one of the ways that recession can be conveyed. Applying this rule to your work will present immediate results.

Using complementary colours is another useful tool. This means that colours which are opposite one another on the colour wheel (shown below) such as blue and yellow or red and green, will make each other seem brighter and will stand out. This can be used to good effect in flower painting, for example where a yellow bloom will appear brighter against a blue background or a red bloom with a green background.

The colours shown in the chart opposite constitute the basis of my own pastel collection and are the ones that I find valuable for both landscape and flower painting. You will note that within some colours, several tones of that colour are represented. This is because although you can modify the tones with white to an extent, it is much easier to have the correct tone to hand.

The bottom left of the chart shows all the various greys such as blue-grey, purple-grey, red-grey and green-grey. These are mainly the colours that I employ to paint the soft, misty background tones which suggest a sense of recession in a painting.

Radiating out from the bottom left towards to top right, all the brighter colours are shown, including earth colours and some of the more vibrant shades that are useful for flower painting.

The names of the colours used in the demonstration paintings in this book are generic as each brand of pastels uses a different method of describing the colours.

My basic palette of colours for painting both landscapes and flowers in pastel.

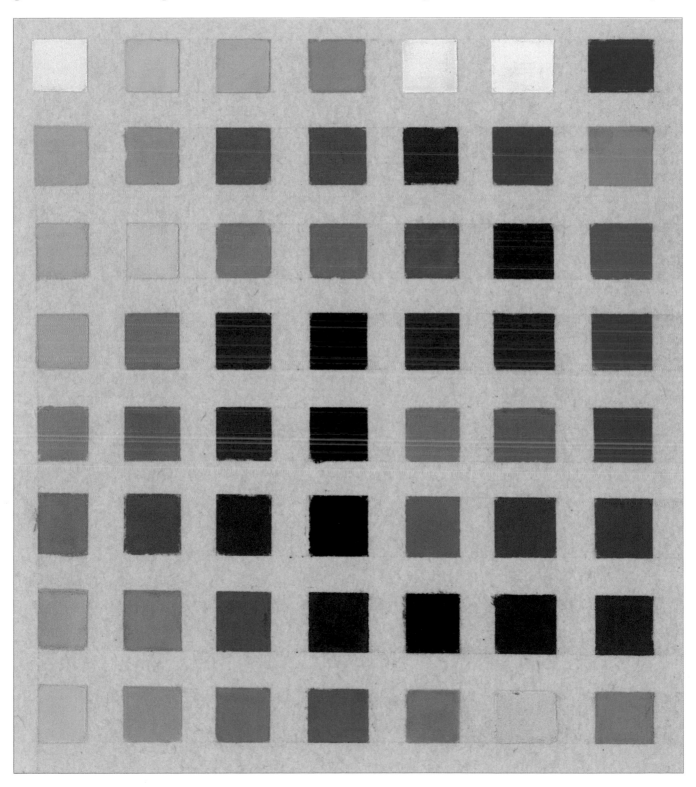

TECHNIQUES

Before you start to use a new pastel, remove the paper wrapping, as leaving it on will inhibit the full range of possibilities. I also break the stick in half, as this provides a more usable size.

MAKING BROAD STROKES

Holding the pastel along its length, stroke the colour on with firm pressure. This gives good coverage. Lift the pressure to create texture – the lighter the pressure, the more broken the colour will be. This lifting of pressure can be equated to the dry brush technique in watercolour.

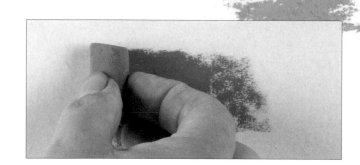

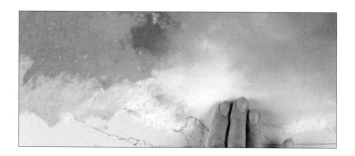

BLENDING WITH FINGERTIPS

Blending large areas such as the sky, is best achieved with the fingers, or the heel of the hand. If you are painting on to an abrasive surface, make sure you have plenty of pastel on the paper first so that you do not chafe your skin. If you can feel the grain of the surface, then add more pastel before continuing.

USING THE TIP OF THE PASTEL

When drawing a solid object, you can outline the shape with the tip of the pastel, turning it to find the best edge available, and then fill in the shape with a broader stroke.

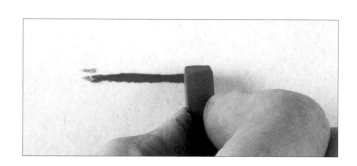

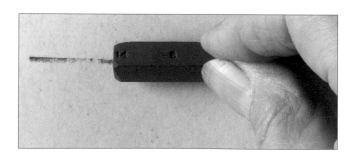

USING THE EDGE OF THE PASTEL

For creating a straight but broken line, such as a ripple on water or a distant telegraph pole, the long edge of a pastel stick which has been worn to a square, sharp edge is handy. A broken line is often more pleasing than a solid one and you can be sure that it will be straight if you use this method. Just press the edge into the surface of the painting rather than pushing it back and forth.

USING COLOUR SHAPERS

To blend areas that are more intricate or too small for your fingers,
a colour shaper is effective.

Tip

Wipe excess pastel from the tip of the colour shaper with your absorbent cloth so that stray colour is not transferred where it is not wanted.

Making neat edges

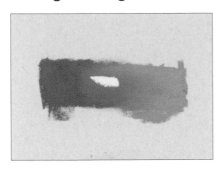

1. The band of white in the middle of this brown area is an uneven shape.

2. Using the colour shaper, you can push the pastels around to create neater edges.

Tip

A size 2 colour shaper is good for small spaces where blending with your finger would just create a mess.

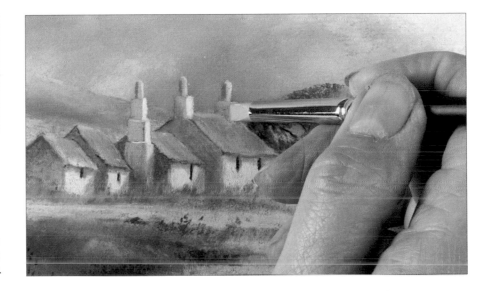

Here a colour shaper is being used in the later stages of a painting to create neat edges for a chimney.

Removing mistakes

You can also use the colour shaper to tidy up mistakes, for example to remove a smudge of colour in a small space between features where your finger would cause damage to the surrounding painting. Here, an unwanted area of white is being removed.

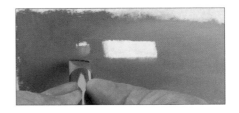

Softening colours together

You can soften colours together with a colour shaper, for example under the eaves on a building where the top edge of the shadow must be sharp and the bottom fades into the wall. This example comes from the *Farm in a Landscape* project beginning on page 84.

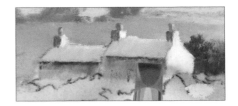

STIPPLING

Dots of colour applied in the pointillist manner are very effective and you could paint in this way over the whole painting if you wanted to. I personally find it too time-consuming for a whole painting, as I am an impatient painter. However, it is ideal for areas of the foreground to indicate seed heads of small flowers or the foliage of trees and plants.

Try to make the dots different sizes and shapes, as shown below, and vary the distance between them to give a natural look.

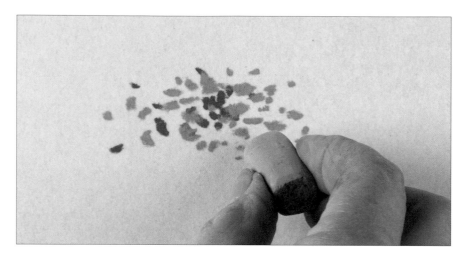

Tip

To give the impression of receding undergrowth in a foreground, stipple in some colour, blend the bottom edge downwards with your fingers and then apply another layer of stippling in a different tone, or colour over the blended area to indicate layers of foliage or flowers.

Here, white flowers or perhaps seed heads are being stippled on with white pastel.

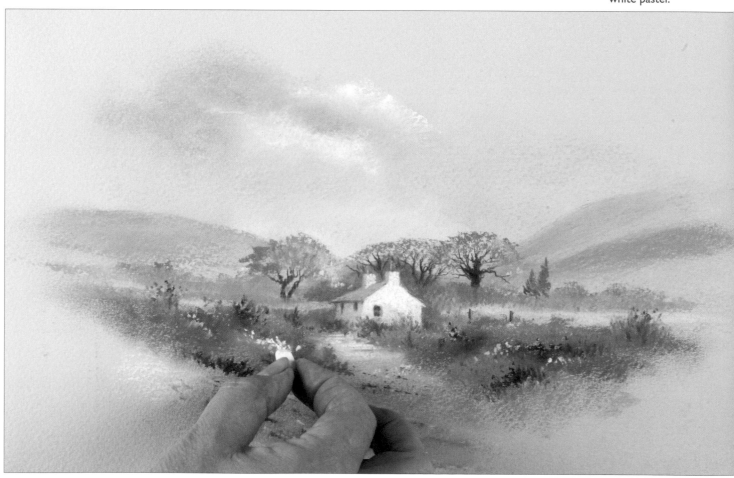

20

FLAKING

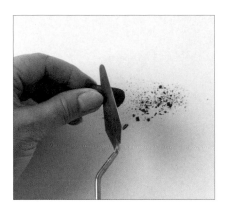

1. Lay your board flat on a table and use the edge of a palette knife to scrape flakes of pastel from a pastel stick on to the surface of the painting where you want to create fine specks of colour.

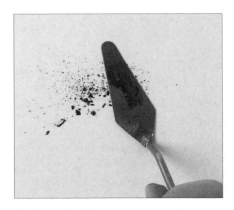

2. Press the flakes into the surface of the paint with the flat of the palette knife where you want them to stick. Blow away any unwanted flecks.

Adding highlights with flaking

1. The flecks will be more effective if you use contrasting tones and colours. i.e. light flecks over a dark background and dark flecks over a light background. Here I used yellow pastel with the flaking technique to suggest highlights in the foliage.

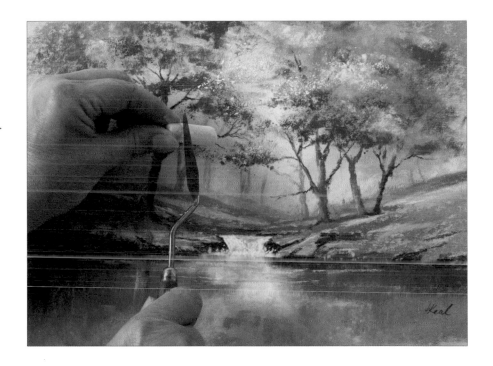

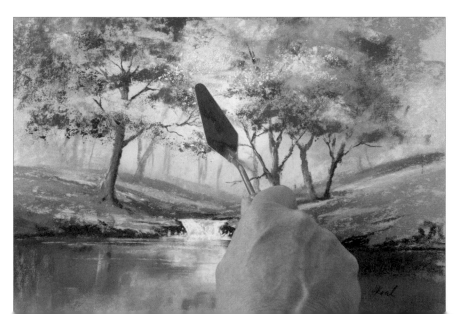

2. I then pressed the flakes into the surface of the painting with the flat of the palette knife. If you feel you have overdone the flecks (beware, this is addictive) you can blend a few of them to lessen the effect in some areas.

USING PASTEL PENCILS FOR DETAIL

The fine branches of a tree or narrow fence posts are quite tricky to create with a clumsy pastel stick, so a sharp pastel or charcoal pencil provides a practical alternative. By combining dark and light colours, you can give the impression of light and shade on the trunk and branches and by using different amounts of pressure as you draw, you can suggest the branches getting thinner towards the top of the tree.

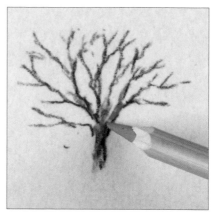

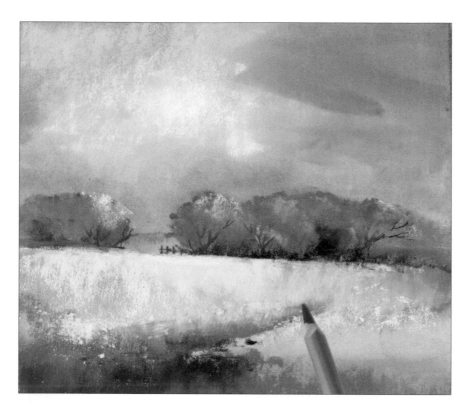

1. Here I used a pastel pencil to add detail to the grassy area in the foreground. Stems of crops can be added in places to add depth to the track through the field. Light and dark strokes adjacent to each other are effective. Make the strokes longer in the foreground and shorter in the distance.

2. A lighter toned pastel pencil was used to add highlights to one of the trees in the middle distance to suggest light on some of the branches. Weave the branches in and out of the foliage to suggest that some of the foliage is obscuring part of the branch. This lends a realistic impression to the tree. It is rare that you can see the whole length of a branch or trunk on a tree in leaf.

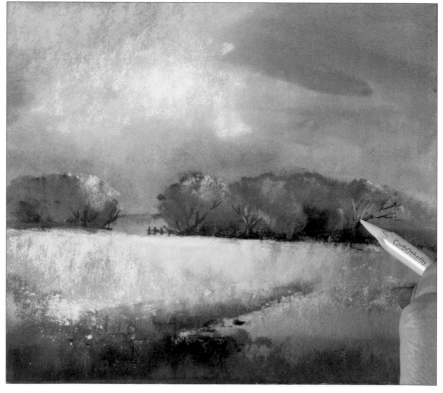

USING FOUND OBJECTS

Abstract foregrounds and passages give a painting interest and variation. It is sometimes difficult to reproduce the random marks your imagination creates, but found objects can be used to produce accidental effects. Some can be used as stencils to produce haphazard images. The object needs to be flat to be effective. They can also be used to create regular patterns; for instance, netting can be used to create the pattern of pig fencing.

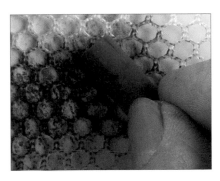

Lay a piece of plastic netting from a washing tablet bag flat on the painting and scrub the pastel across to create a pattern.

Depending on the amount of pressure applied to the pastel, different effects can be achieved.

You can also coat the netting in pastel and use it to make an imprint.

The netting has been used in both ways in this painting in progress: as a stencil and to make an imprint with pastel-coated netting. The hit and miss effect is more casual than drawing the fence carefully with a pencil. You can tidy up any stray marks with the colour shaper. To give a sharper image, try finding a finer netting. You could also spray the underpainting with fixative and once the painting is dry, use this technique for a stronger result.

USING FIXATIVE

As indicated earlier, I rarely spray a finished painting with fixative as it tends to dull the colours and merge the lines, but it can be very useful to spray the work at an interim stage to enable you to paint a light colour over a dark passage without lifting any of the pastel from underneath.

The sheep in this painting in progress does not stand out very well, but adding white pastel to a dark area would not help, as it would pick up the colour underneath and reduce the impact.

Tip
Spraying a finished painting can dull the colours, but fixing the painting at an interim stage is valuable for creating clean, sharp features.

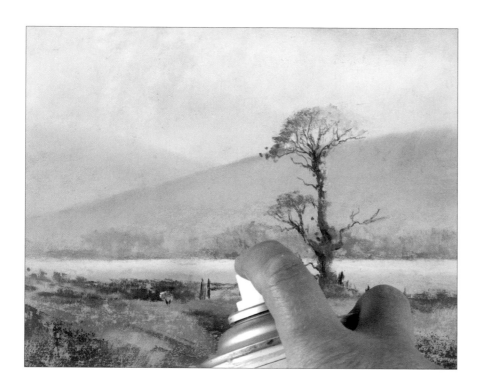

1. Spray fixative over the area where you wish to improve the sheep, following the directions on the can, and make sure you always spray in a well ventilated room. Allow the fixative to dry thoroughly before the next stage.

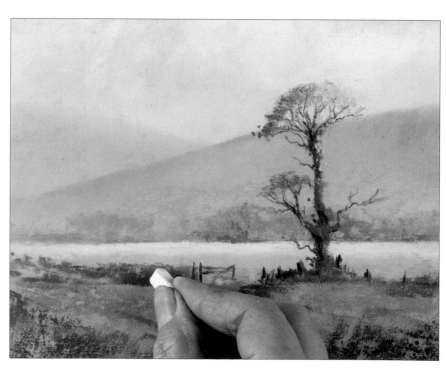

2. The background is now fixed and will not be disturbed by the application of more pastel on top. In this painting, I added white pastel to improve the sheep without affecting the background.

24

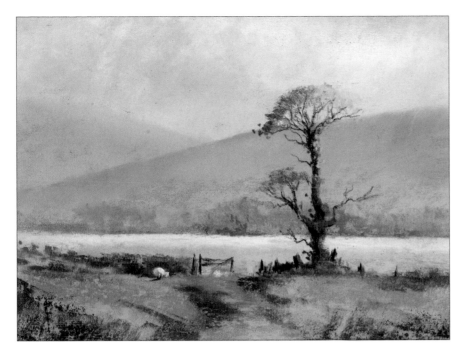

The finished painting. The sheep now stands out better against the hedge and draws the eye to the gate which invites the viewer into the picture.

My preferred method of working is to bring the sky down over the lines in the initial stages to avoid a margin between the sky and what is in front of it. The intense midnight blue of the sky in this painting would have been difficult to paint over with a light colour as the dark pastel would have been picked up by the light pastel and the impact of the cottage and the tree could have been reduced. To prevent this problem, the sky was sprayed with fixative, providing a sealed surface on which to paint the intricate detail. Pastel pencil was used for the fine lines. A fixed surface is very satisfying to work on in pencil, as the lines are clean and bright.

GATHERING SUBJECTS

USING SKETCHBOOKS

The single most effective thing you can do to improve your painting is to take up sketching outside. This improves not only your drawing skills, but also your observation and appreciation of the subtle nuances of colour and tone in nature, which a photograph can never reproduce. You will begin to see things more intensely, you will notice the way the light affects the landscape, and being out of doors will take on a new significance and become more rewarding. Even if you are not very mobile, it is possible to work from a car.

Many of us keep a holiday diary, but making a sketchbook journal of your travels adds a charming new dimension. I find that looking through my illustrated journals brings back so much more than just the words on the page. It recalls the moment more profoundly, including the smells and sounds, and evokes special memories.

Once the sketchbook habit is established, you will find that you are never short of a subject to paint, as your sketchbook collection provides a resource of inspiration. Leafing through the pages will soon spark an idea for a painting.

On overseas trips I like to keep a sketchbook journal in an A4 hardback sketchbook, which are more robust than ring-bound sketchbooks and more likely to survive the rigours of travelling.

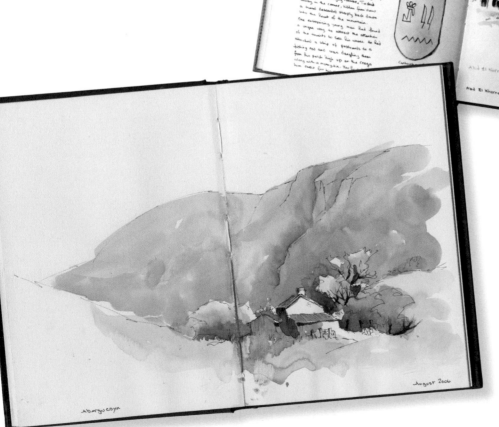

An A5 sketchbook will fit comfortably into a handbag or a waist-bag. You do not need to carry around a lot of materials in order to carry out quick sketches. I can fit all my watercolour sketching kit into a school pencil case.

Capturing the essence of a scene quickly calls for the correct materials. For creating atmosphere and reflections, water-soluble graphite pencils are an excellent medium. You can draw the image on the page and then moisten the graphite to create softer effects; emphasise the lighter features by making the dark areas more intense; or suggest subtle details by picking up the graphite with a damp brush and using it to paint delicate nuances of tone.

Authentic depictions of reflections in water can also be produced with water-soluble graphite. The lightweight nature of a pencil together with a water brush for moistening the graphite, means that quick sketches can be done without the need for a lot of equipment. This provides an incentive to carry out quick sketches on family days out or a ten minute break on a journey.

Moistening the water-soluble graphite in this sketch highlights the falling water.

In the sketch below, the dark reflection of the trees defines the edge of the water and softening the graphite with water blends the tone from dark to light.

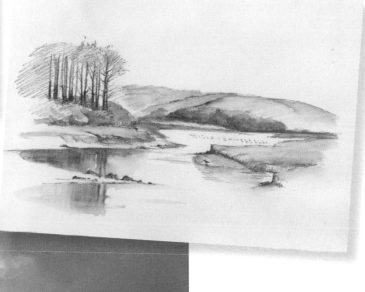

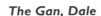

The Gan, Dale

34 x 24cm (13³/₈ x 9½in)

The painting done from the sketch shown above. Painting reflections in pastel is very satisfying. Apply the colour of what you are reflecting and drag the colour downwards with your fingers to give the water a diffused effect. If this weakens the colour too much, add more colour until the depth of tone you require is achieved.

27

WORKING FROM PHOTOGRAPHS

Photographs can be useful as part of your reference material, but the danger of relying solely on static photographic images is that you tend to reproduce every detail in your painting. If you have to work from photographs, make a studio sketch first in order to filter out a lot of the less important detail and to determine the most important features that you want to emphasise. The ideal is to have both a sketch and photographs to work from.

Wherever possible, it is best to paint from your own photographs because at least you have some visual memory of the location. Knowledge of a place, however slight, gives your painting authenticity.

This photograph of Lingcove Bridge was taken in poor light and shows little of the colours that were on the bridge. A sunlit photograph would have revealed the subtle colours in the stone which could be easily observed with the naked eye, even on such a dull day.

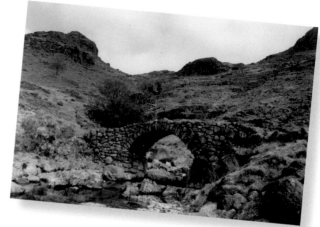

Lingcove Bridge, Cumbria

24 x 33cm (9½ x 13in)

In the photograph and the sketch, the detail in the background fell distracts the eye from the focal point, the bridge. In the painting, I have softened all the background detail and emphasised the colour and detail on the bridge.

The watercolour studio sketch helped me to resolve the problem of the lack of colour in the photograph and my visual memory of the scene helped me to recall the colours.

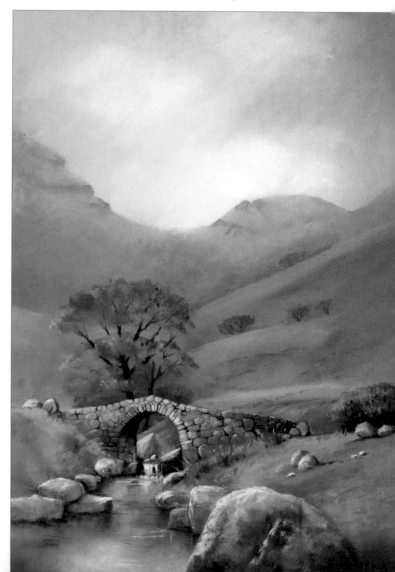

GATHERING REFERENCE FOR FLOWERS

The flowers you want to paint will depend on whether you have a garden and enjoy growing flowers; if you are fond of visiting gardens; or if you prefer wild flowers.

Sketching in your own garden is obviously the best option as you can choose your moment to photograph and sketch the blooms when they are at their best and the light is just right. You can also grow the species that are your favourites and sit in privacy and comfort. Drawing in a friend's garden, a public park or show garden would be a pleasant alternative. If you can find a quiet corner to sit and sketch, all the better, but do not be shy of sketching in public. Most people will envy you and wish they were having a go themselves.

This hanging basket of giant fuchsias is positioned just outside our dining room window so that each mealtime I can judge if the light is at its best for drawing and photographing them. This photograph was taken at breakfast time.

Making a detailed pencil sketch of your subject helps to resolve many issues such as the tonal values, the positioning, what to include and what to leave out. It is better to make these decisions in a pencil drawing than to keep changing your painting.

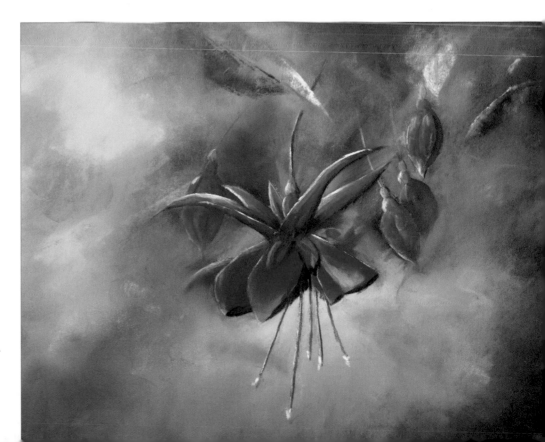

Giant Fuchsia

26 x 22cm (10¼ x 8⅝in)

Capturing the light on the rims of the petals was my main objective here, but in the photograph you can barely see the detail in the skirts of the flower. The detail gathered in the sketch helped me to combine the two elements.

COMPOSITION

Composing your painting starts at the sketching and/or photography stage. Once your attention is drawn to a subject, you have to decide what is the most important feature and what made you want to paint it. This will be your focal point, where you want the eye of the viewer to rest in the painting. You then need to filter out unnecessary or competing features and use the sky, the background and the foreground to lead the eye towards your focal point. In order to keep the interest on that focal point, use stronger and contrasting tones, warmer colours and more detail around it.

In a landscape painting, the size of the focal point is also important. So, for example, if your focal point is a building in the landscape then you should leave room for the landscape by not making the building too big. Below is an example of a mistake I made by copying a close-up photograph of a building instead of referring to my sketch.

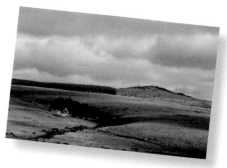

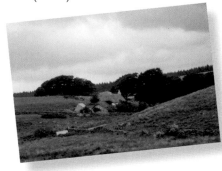

I took two photographs of the scene, Old Smith Farm and Bellever Tor; one to include the background tor (above) and another to give me the detail on the farm (below).

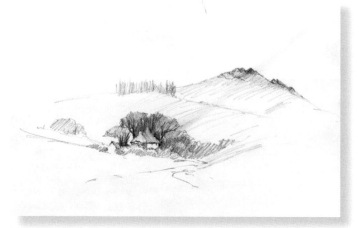

In the sketch done on the spot I have made the farm slightly bigger so that I could capture some of the detail on the building.

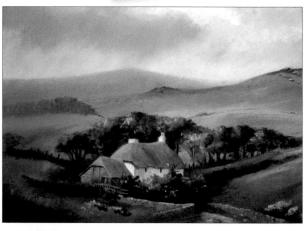

My inspiration for this painting was the light on the moor with the tor in the background. However, in this first version, I painted the farm far too big so that it dwarfs the tor in the background and dominates the foreground, distracting the eye from the lovely light on the moor.

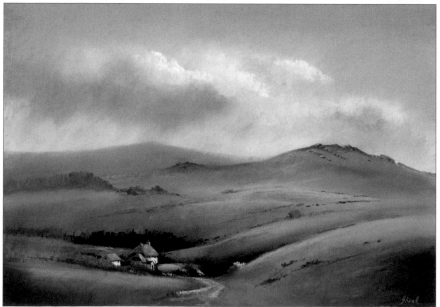

Old Smith Farm and Bellever Tor, Dartmoor (corrected version)

35 x 25cm (13¾ x 9¾in)

With a stiff brush, I removed the buildings and repainted them as well as the fields and the supporting trees smaller, without changing the background of the tor. This allows the eye to travel towards the farm and then continue towards the tor.

MOVING THINGS TO AID COMPOSITION

Hedgerows, trees, animal tracks, roads and paths can all be used to draw the eye towards the focal point in a landscape painting. Often a fence or hedgerow travels horizontally in front of a building, cutting off the viewer from the focal point. Instead of painting it as it is, turn the hedge so that it leads to the building; or leave it out; or replace it with a track.

Trees can be moved so that they frame one end of the house, providing a strong contrast in tone, or animals that are scattered about a field can be grouped together near the building so that they do not compete with the focal point.

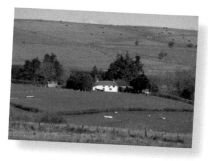

The hedgerow in the foreground of this scene creates a barrier to the eye, preventing the viewer from reaching the focal point. Also the hills in the background are straight across with no interest. The trees around the building are too dense to penetrate, creating another barrier.

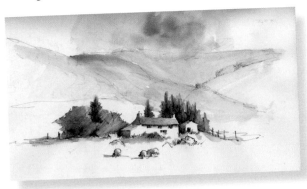

In my sketch I have left out the hedgerow across the foreground and moved the sheep closer to the building. I have given the background hill some shape and interest and the density of the trees around the building has been reduced.

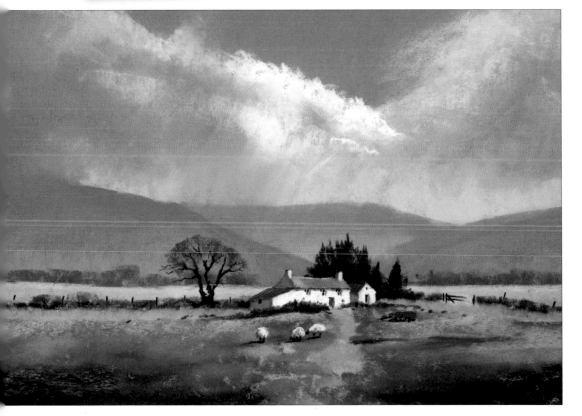

Blaenfirnant

32 x 20cm (12⅝ x 7⅞in)

Having resolved some of the difficulties with the scene at the sketching stage, I changed things further in the final painting. The hedgerow that was left out of my sketch has been replaced with a rough track which leads the eye straight to the front door. I have also left out more of the trees surrounding the farm so that the landscape beyond is more visible, which helps create a sense of space in the painting. The atmosphere over the background hills aids recession and gives the viewer the opportunity to move on through to other imagined landscapes.

LEAD-INS

There are a number of features used in the painting *Blaenfirnant*, shown above, to lead the eye to the focal point of the buildings. The track goes to the front door, the clouds converge above the buildings and the background hills slope towards the focal point. I have also moved the sheep closer to the buildings so that they do not distract the eye. Using strong tones around the focal point and touches of red on the building also give the viewer no doubt about our message.

COMPOSING FOR FLOWERS

Many of the rules of composition for landscapes apply to composing a flower painting too. It is important to have one focal point, to lead the eye to this focal point using stems and leaves, and to use stronger tones and more detail around the flower which forms the focal point.

Flower paintings also benefit from an element of design in the shapes created by the arrangement of the blooms. When choosing which blooms to include, how they are placed and which one will be emphasised, bear in mind the shape the grouping creates. An arc, a crescent shape or a triangular arrangement is pleasing. Square or round arrangements tend to be less satisfying. Overlapping the flowers and leaves also creates a more realistic image. Some of the flower heads should become smaller and less detailed as they recede into the distance. This will give the illusion of space in the painting. Use a background colour designed to complement the colour of the focal point and a combination of soft and hard edges to suggest foliage in the distance.

An 'out of focus' background throws the attention of the viewer on to the flowers. Try using colour to suggest foliage, sunlight and distant trees, and soften the detail by blending the colours together.

Taken in isolation, the individual blooms do not make a satisfying composition.

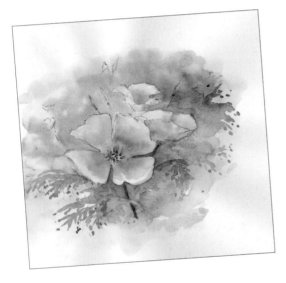

The sketch (left) shows that by combining three of the blooms, or even the same one from different angles, you can create a more satisfying arrangement and introduce a sense of depth and perspective.

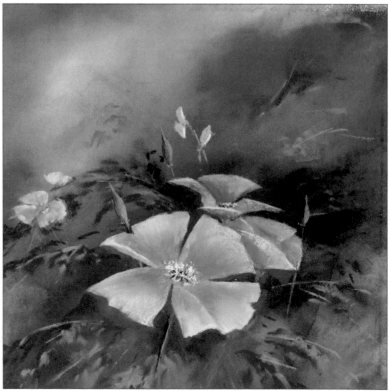

Californian Poppies
20 x 20cm (7⁷/₈ x 7⁷/₈in)

The background foliage has been suggested with colour rather than detail, keeping the focus on the main bloom. The overall shape suggested by the grouping of the flowers is a sweeping arc receding into the distance.

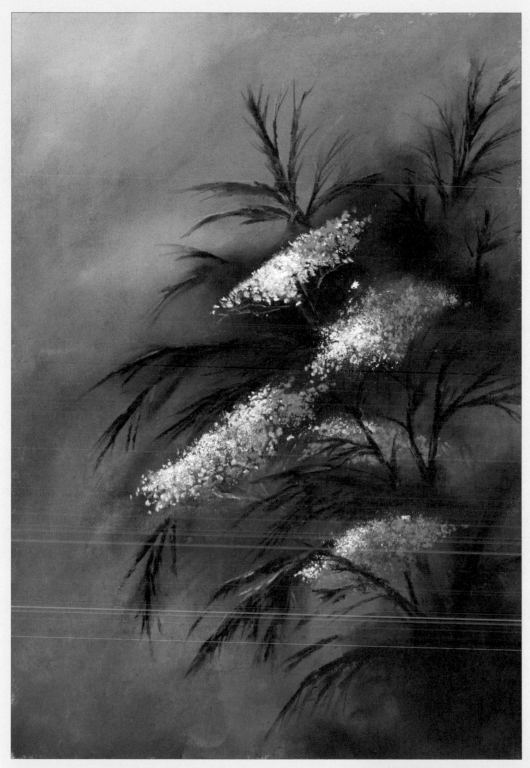

Sambucus (Black Elder)

24 x 33cm (9½ x 13in)

The dramatic contrast of the virtually black foliage with the pink and white blossom compelled me to paint this black elder where it grows outside my studio window. It almost dazzles in strong sunlight. Each spray is comprised of tiny flowers which I painted using the flaking method, overlaying white and pink flecks of pastel and pressing them into the surface with the flat of a palette knife until the required shape and density of colour emerged. The dark, pinnate leaves were suggested by holding the pastel stick lengthwise against the paper and scuffing feathery shapes outwards from the centre of the leaf, then flicking in some finer lines.

Oriental Poppies

22 x 22cm (8⅝ x 8⅝in)

I made the large foreground bloom the focal point by giving it sharp edges and more detail. The rest of the flowers were slightly softened to make them recede a little. The flowers emerge from the bottom right of the painting, allowing the eye to float over them towards the light background.

RECESSION

Creating a sense of depth or three-dimensional space in our paintings is one of the most important skills to learn. There are a number of ways to create this illusion and the most effective is the use of colour, tone and detail.

The first principle is that cool colours recede, and warm colours advance. This rule will help you choose the colours for distant features from the cool end of the spectrum and reserve warmer colours for the middle distance and foreground.

The second device you can use to create the impression of depth is to use paler tones in the distance and stronger, darker tones as you paint the nearer features. Use your strongest darks and lightest lights around the focal point to draw attention to it.

The third technique is to avoid too much detail in the background features and emphasise the definition around your focal point and in the foreground. However, beware of putting too much detail in the foreground as it can detract from your focal point.

Pembrokeshire Cottage

20 x 23cm (7⁷/₈ x 9in)

I have used all of the rules of creating recession in this painting. The distant hills are blue, the tones in the distance are paler, and there is little detail. Around the focal point there is strong contrast between the white cottage and the dark foliage, and the foreground colours are warm. There is also a sense of perspective on the rough path which is widest at the bottom and narrower as it retreats. All these devices create the illusion of space in the landscape.

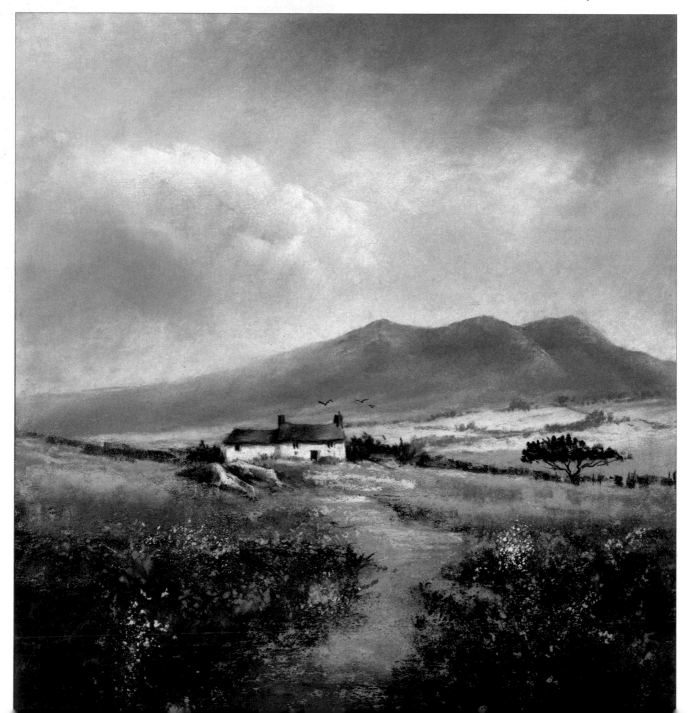

AERIAL PERSPECTIVE

I have explained opposite how cool colours recede and warm colours advance. This is aerial perspective. If you stand outside, where you can see for some distance, ideally where there are trees, at first glance you will perceive the distant trees as the same colour as the ones nearer you. Now half close your eyes and look again. You will notice that the distant trees are less distinct, cooler in colour and less detailed than those close to you. This disparity is because our brain often fills in information, thinking: 'Those trees in the distance are the same as those closer to me, therefore they must be the same colour'. Once you have observed this phenomenon, you will find it easier to discern the real colour and tone in the landscape in future. The strength of this effect will obviously vary according to the weather and atmosphere.

LINEAR PERSPECTIVE

Linear perspective is geometry. Find a straight line of fencing and position yourself so that your eye is halfway down the fence. Look along the length of the fence and you will see that the top of the fence goes down as the fence disappears into the distance. If the fence is long enough, it should disappear altogether at the horizon. This is your eye level. When you stand up, the linear perspective changes so that the top bar now rises to meet that eye level on the horizon. This principle applies to buildings and other objects in the landscape. A distant tree will appear smaller than a foreground one. Use this as another device to capture that sense of space in a landscape.

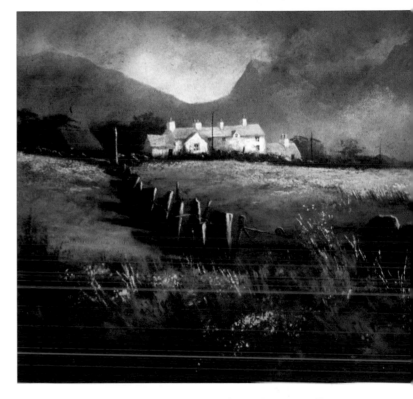

People find linear perspective most difficult when drawing buildings. The complication of a three-dimensional object makes observation the key to success. Study the angle of the eaves, the roofline and the baseline, using your pencil to decide whether they are above or below your eye level. Holding the pencil at arm's length, line it up with the eaves of the building and you can immediately see if the line goes up or down as it recedes. Use this as your benchmark for the rest of the drawing, checking the other features with your pencil at arm's length as you go. This will build up your confidence and eventually you will be able to draw the building without all the measuring and checking.

FOREGROUNDS

I prefer to keep foregrounds fairly simple or abstract, as a complicated, detailed foreground can detract from your focal point. However, you can use tall grasses, seed-heads and random flowers in the foreground to aid the illusion of depth, varying the size of the grasses along a path to draw the eye in. Abstract foregrounds can be effective and you can substitute colour for detail to suggest foliage or wild undergrowth with just a hint of detail. Leave something to the imagination of the viewer.

Slate Fence at Fron, Snowdonia

25 x 25cm (9¾ x 9¾in)

This fence is made of slabs of slate from the nearby quarry, held together with wire. It illustrates the effect of linear perspective in a landscape as an aid to creating the illusion of distance.

Tip
To understand perspective on buildings, practise drawing a box from different viewpoints and heights.

35

STEP-BY-STEP
DEMONSTRATIONS

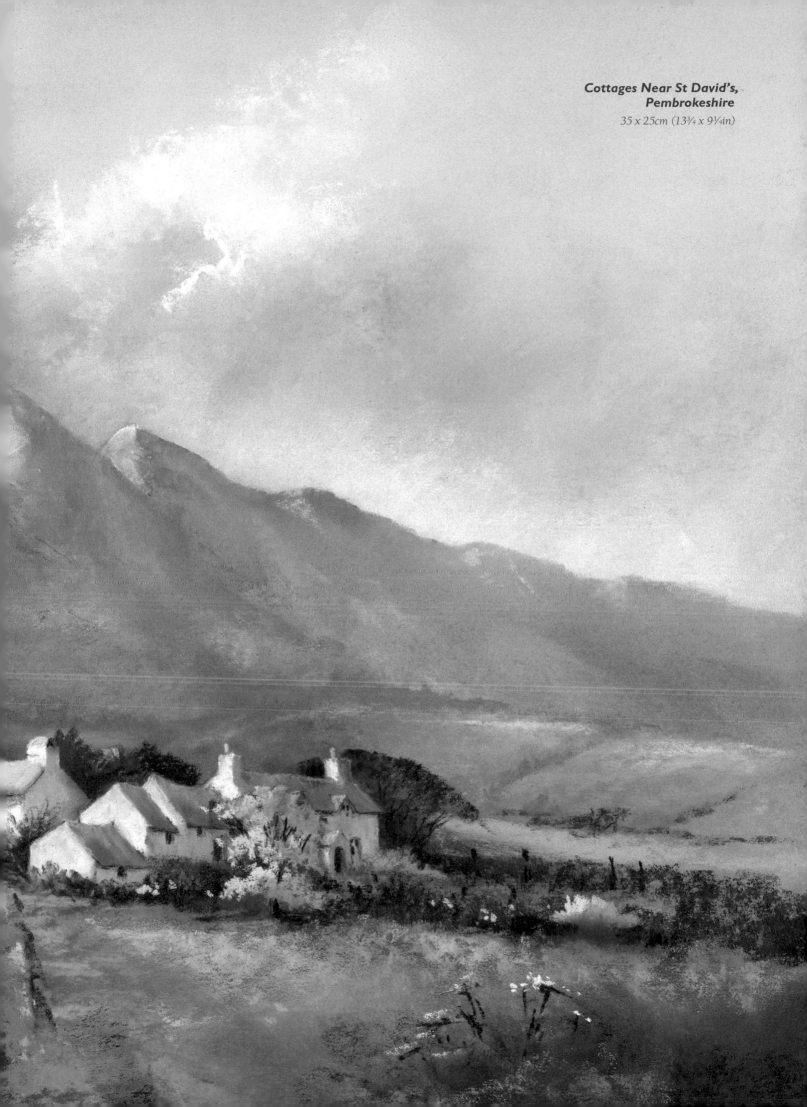

Cottages Near St David's, Pembrokeshire
35 x 25cm (13¾ x 9¾in)

Barn and Mountains

SIMPLIFICATION

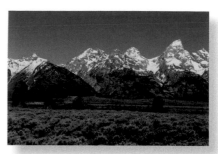

I sketched and photographed this old barn in Wyoming on a trip my husband David and I made in June 1993. In the photograph there is a lot of detail on the Grand Teton Mountains in the background and I decided to simplify this detail considerably in my sketch and to an even greater extent in the finished painting.

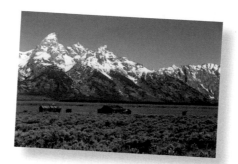

There was still quite a lot of snow on the mountains, which gave them a rather patchy appearance, so I decided to paint snow only in the gullies and ignore the patches of snow on the vertical faces of the mountains. This would help to simplify the background and emphasise the sense of distance between the barn and the mountains. I also made the mountains paler in tone than they appear in the photograph, especially the lower slopes.

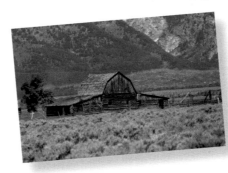

The sage brush prairie in the foreground is cool in colour but foregrounds benefit from warm colours, so I applied darker tones in the foreground to aid recession. The path through the sage brush was introduced to lead the eye to the focal point, the barn. The warm colour on the barn identifies it strongly as the focal point and to reinforce this, I used strong tones on the shadow side.

My sketch of the scene.

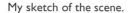

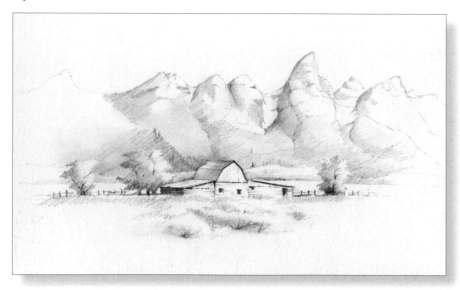

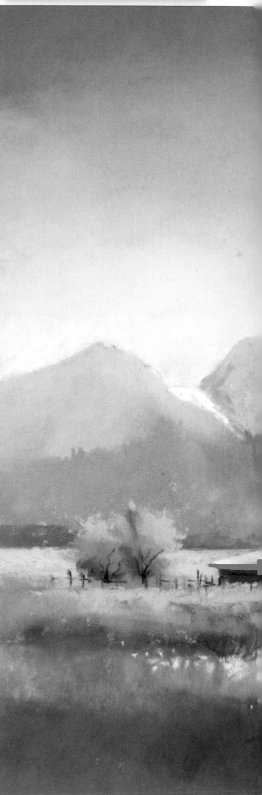

38

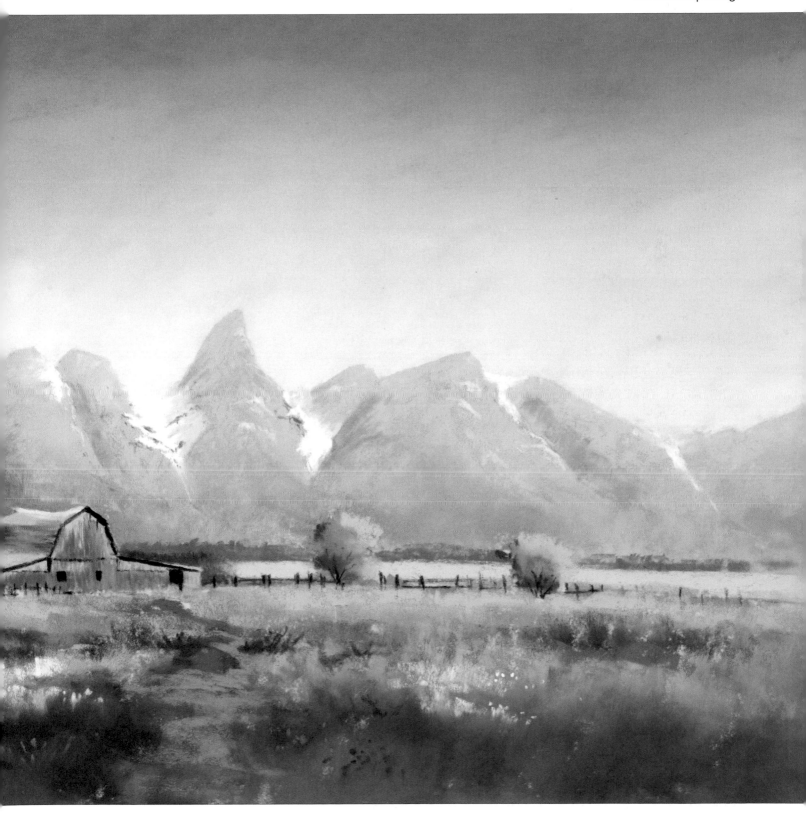

The finished painting.

You will need

Artist grade sandpaper,
36 x 26cm (14¼ x 10½in)

Pastels: dark cobalt blue,
cobalt blue, light cobalt blue,
Naples yellow, pale blue-grey,
pale red-grey, white, very
pale blue-grey, pale purple-
grey, green-grey, pale green-
grey, pale sap green, bright
lizard green, dark sap green,
dark green-grey, pale raw
sienna, burnt sienna, orange,
red-grey, dark purple-grey,
purple-brown

Pastel pencils: grey, white

Charcoal pencil

Size 6 colour shaper

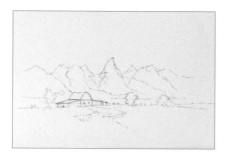

1. Draw the scene in charcoal pencil.

Tip

Use charcoal pencil for the initial drawing rather than graphite. Charcoal will blend into the pastel whereas graphite will not.

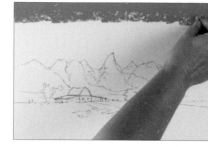

2. The Wyoming sky is an intense blue, so start at the top with broad strokes of dark cobalt blue.

3. Put in a medium-toned blue lower down the sky, with cobalt blue.

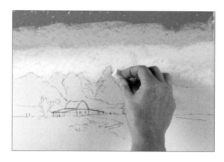

4. Use a light cobalt blue lower down, then add Naples yellow at the bottom of the sky, going over the very tops of the mountains, so that the sky goes behind the mountains.

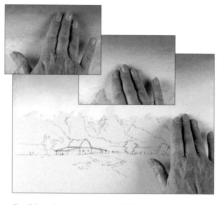

5. Blend the top two blues together by rubbing with your fingers, then wipe your hands clean and blend the middle and lower blues in the same way. Wipe your hands clean again, and blend the Naples yellow into the bottom blue.

6. Put in the shadowed sides of the mountains with a pale blue-grey. This colour is cooler than in the reference photographs to help make the mountains recede.

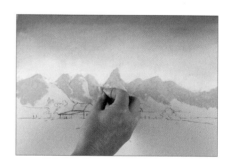

7. Use a pale red-grey to put in the right-hand sides of the mountains, which are lit by a very pink afternoon sun.

8. Use a white pastel to paint the highlighted snowy areas in the gullies, some of which are glaciers.

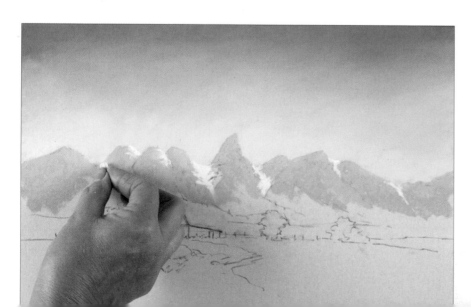

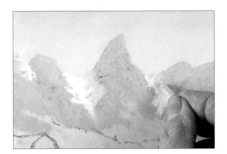

9. Add a little shadow to the snowy areas with a very pale blue-grey.

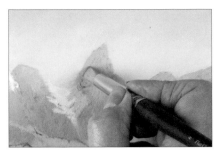

10. Use the size 6 colour shaper to tidy up any shapes that look too soft-edged and not rocky enough. Also remove some charcoal marks.

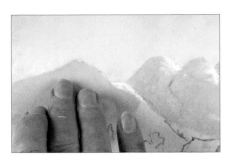

11. The mountains at the edges need to have a smoother, less detailed look so that they are not the centre of attention. Use the colour shaper and your fingers to blend and smooth.

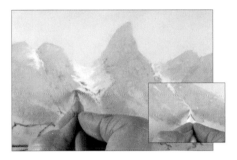

12. Add rocks within the snow with a grey pastel pencil, then use a white pastel pencil to add details of the light catching rocks.

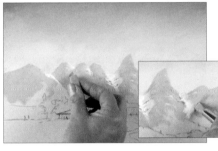

13. Use a purple-grey pastel to paint shadow in the gullies, then use a colour shaper to make sure the shadows extend right to the bottoms of the gullies.

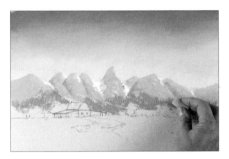

14. Now paint the lower parts of the mountains going down to the trees with little strokes of green-grey, keeping some of the texture. Use a pale green-grey to create lighter tones at the top of this area.

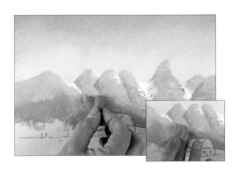

15. Hint at trees on the ridges with green-grey, moving the pastel up and down in a jagged line. Blend at the bottom with your fingers.

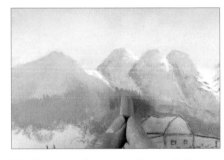

16. Paint another row of trees below the first in the same way.

Tip
Soften the distant features together to help them recede.

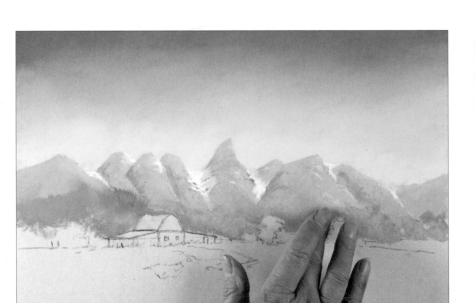

17. On some of the mountains, blend the grey area into the blue above it with your fingers.

41

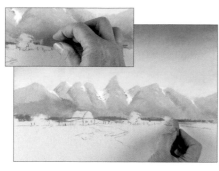

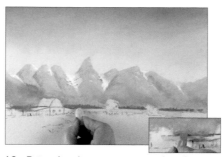

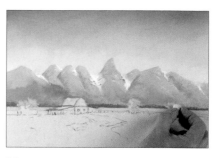

18. Use the flat edge of the dark green-grey pastel to suggest a line of distant trees at the edge of the prairie, then use the tip to vary the height of the trees.

19. Paint the distant prairie with pale sap green, then use the colour shaper to define the tree shapes a little.

20. Use a bright lizard green pastel to paint the sunlit sides of the trees on either side of the barn.

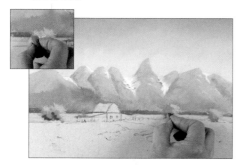

21. Paint the dark sides of these trees with dark sap green, then use dark green-grey to add shadow under the foliage. Soften the tree greens together with your finger.

22. Add a green line along the fence line to define the distant prairie from the nearer with dark sap green.

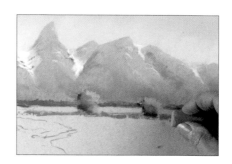

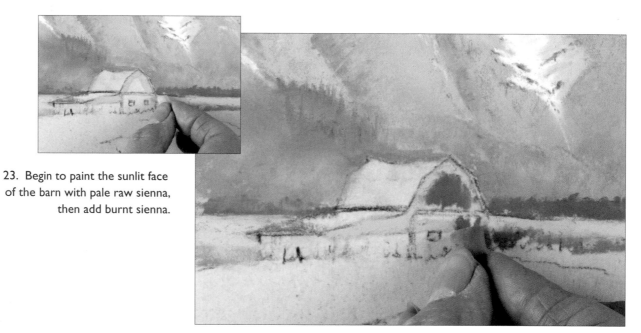

23. Begin to paint the sunlit face of the barn with pale raw sienna, then add burnt sienna.

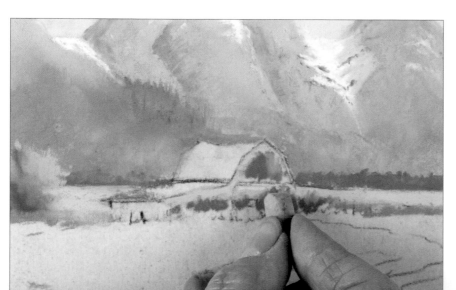

24. Add highlights to the wooden barn front with an orange pastel.

Tip

Do not worry if the initial marks you make look messy; they can be tidied up with a colour shaper, and with pastel, mistakes can be removed or painted over.

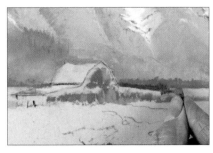

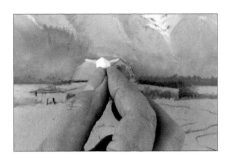

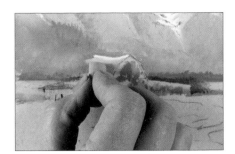

25. At this point the right-hand extension to the barn looked too high to me, so I have cut it back using a dark green-grey for the trees behind it. I softened these in with a colour shaper.

26. Add a line of highlight along the roofline with white pastel.

27. Use a comination of red-grey and pale red-grey to apply texture to the roof of the barn.

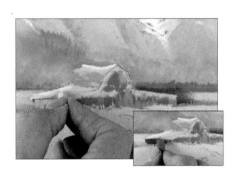

28. Add a white rim to the back of the left-hand roof extension, then paint the rest of it with pale red-grey. Place a dark shadow under the eaves with dark purple-grey.

29. Use the colour shaper to tidy and define the apex of the roof, and to blend the white into the red-grey. Blend from the white of the left-hand extension into the red-grey.

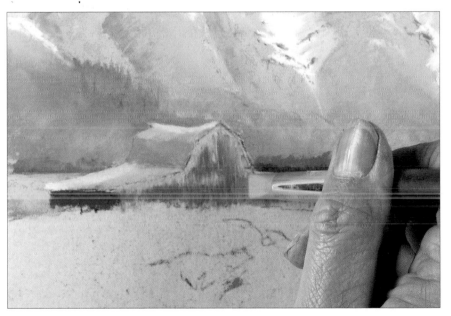

30. Create the impression of planking at the front of the barn by pulling the colour downwards in vertical lines.

31. Add details such as the shadow under the eaves, a door and windows with charcoal pencil.

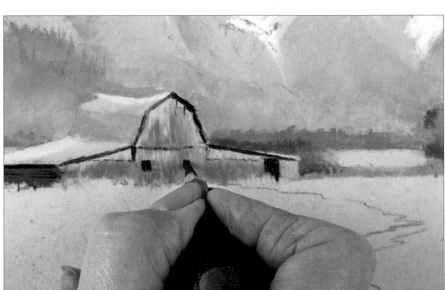

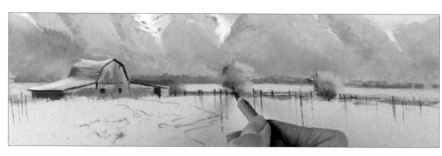

32. Add texture to the roof with purple-brown lines going from front to back. Neaten and blend these with a colour shaper.

33. Use the end of the dark purple-grey pastel to create the fence with little vertical lines, then add the horizontals. Darken some of the posts with charcoal pencil.

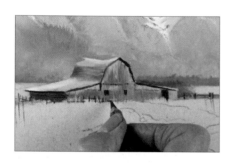

34. Add a bit of broken fence in front of the barn, still using the charcoal pencil.

35. Begin to create the sage brush prairie with pale green-grey. This should hide the bottoms of the downward strokes of the fence.

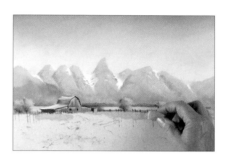

36. Indicate the path sketchily with green-grey.

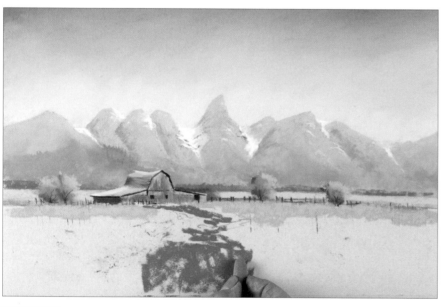

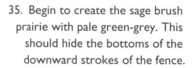

Tip

Direct the eye to the focal point, the barn, by introducing a rough path through the sage brush in the foreground. Make the path disappear in places and make it narrower as it recedes.

37. Continue the sage-brush prairie with a line of green-grey and then dark green-grey, using the texture of the sandpaper.

38. Break up the dark line with more green-grey.

39. Apply more pale green-grey coming forwards, indicating foliage with random strokes so that it looks natural.

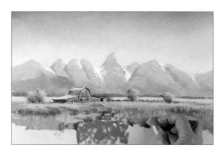

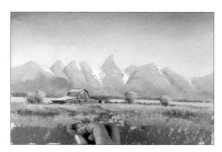

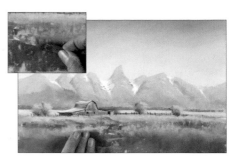

40. As you come forwards, add more green-grey, but then introduce a warmer green, dark sap green.

41. Bring the green to the extreme foreground with green-grey.

42. Add marks with dark green-grey, then blend here and there, randomly, with your fingers, leaving some areas unblended.

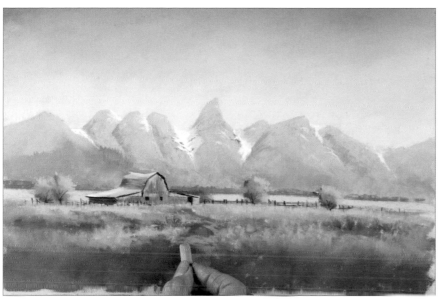

44 Paint twigs under the sage brush bushes with dark green-grey.

43. Add red-grey to re-establish the path.

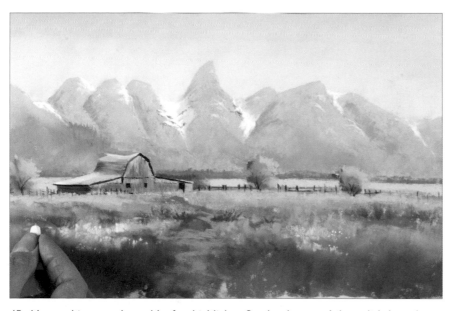

46. Finally, stipple texture at the front of the painting with dark green-grey.

45. Use a white pastel to add a few highlights. Stroke the pastel down lightly and then dot with it.

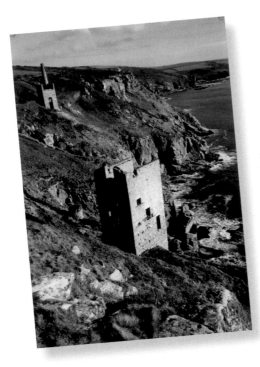

In this photograph of a tin mine, the sunlit rocks and the surf at the base of the cliffs present the challenge of too much detail. Also the two ruined wheelhouses compete with each other to be the focal point.

Cornish Tin Mine
35 x 25cm (13¾ x 9¾in)

Leaving out a lot of the rocks and replacing them with sweeps of colour helped me to simplify the scene. I placed the nearest wheelhouse so that it emerges from the bottom of the painting, meaning that the eye is drawn over it and onwards towards the distant wheelhouse. The detail on the far headlands is softened to help them diminish into the distance.

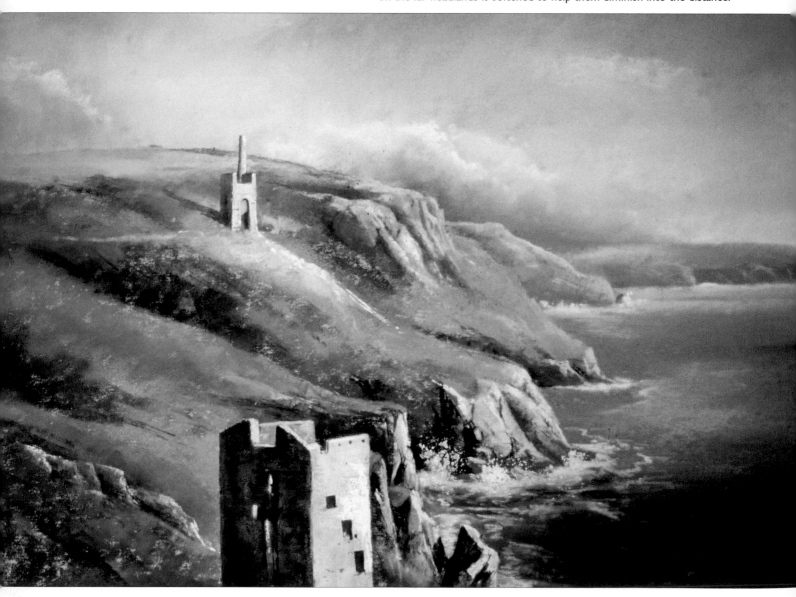

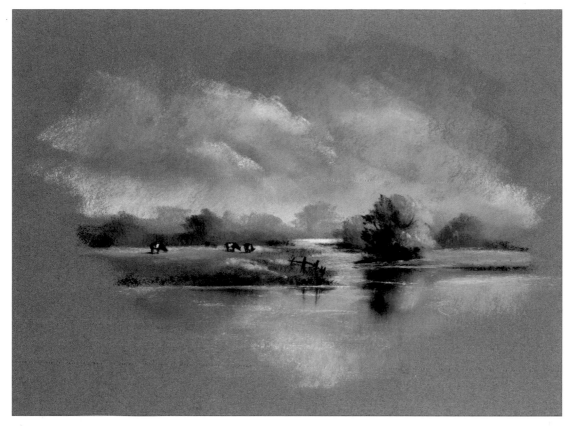

Watermeadows

28 x 21cm (11 x 8¼in)

A different way to simplify a scene is to vignette the painting. Use a tinted paper that complements the picture. In this painting I have used an ochre colour to pick out the colour of the dead grasses beside the water. Backgrounds in subtle tones or more vibrant colours can be used to give varying effects. If you wish, you can use an acrylic or watercolour underpainting on an abrasive surface, such as a specialist pastel paper.

Farm Below the Crags

22 x 23cm (8⅝ x 9in)

In the low evening light, every rock on the crag was clearly visible, so to make it recede and not compete with the farm, all the detail had to be ignored and just the basic shapes indicated. Try half closing your eyes when confronted with a mass of detail and the basic shapes should emerge.

Coastal Scene

CREATING ATMOSPHERE

Pastel is a most amenable medium for creating atmosphere. The ability to blend colours together, the wide range of subtle tones as well as vibrant colours and the ease with which the painting can be changed or corrected, give you the freedom to express yourself.

Rickets Head in Pembrokeshire is one of my favourite subjects; I have painted it many times in different moods. The photograph shows it clearly defined without much going on in the sky. In the two sketches, produced on different visits, I have captured varying types of atmosphere.

In the painting I have combined elements from each of these references. The figures and their reflection provide a focal point.

The reference photograph.

The water-soluble graphite sketch.

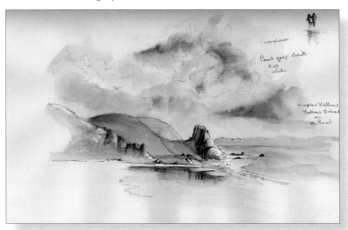

The watercolour sketch.

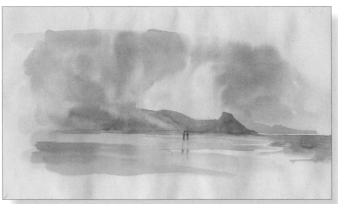

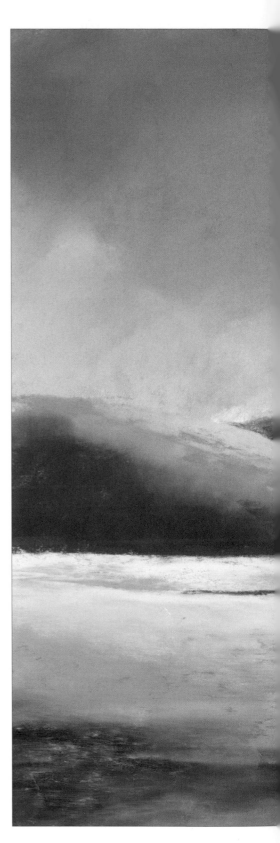

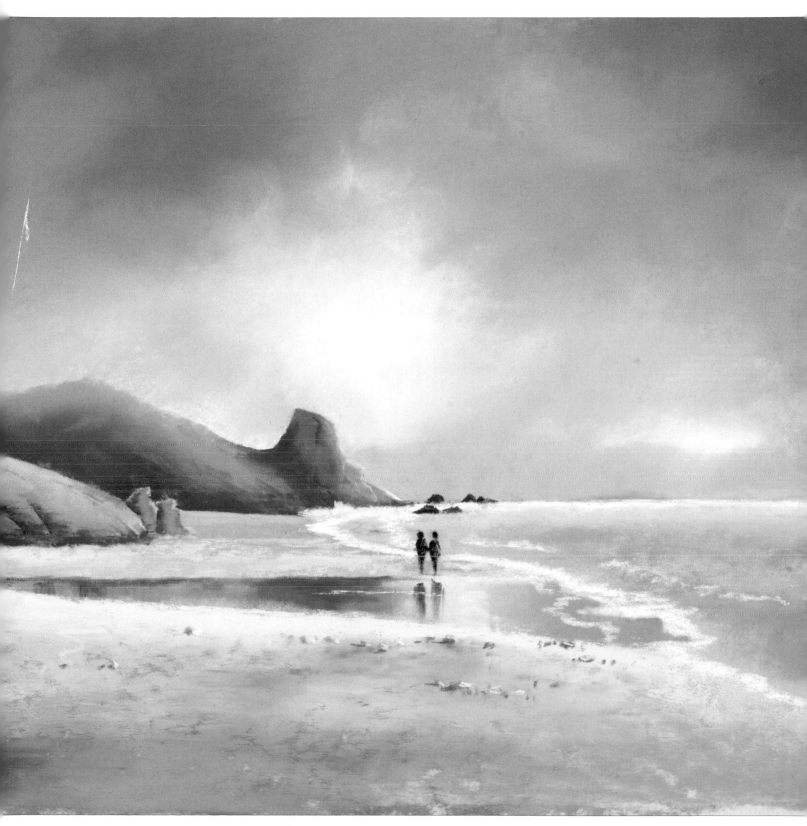

The finished painting.

You will need

Artist grade sandpaper, 36 x 26cm (14¼ x 10¼in)

Pastels: pale Naples yellow, red earth, pale purple-grey, pale blue-grey, dark purple-grey, purple-grey, blue-grey, white, pale red-grey, very dark purple-grey, pale sap green, green-grey, very pale pink, turquoise, dark blue-grey, very pale burnt sienna, red-grey, very dark green-grey, dark purple-brown, purple-brown, pale pink, pale burnt sienna, very dark red-grey, sap green

Pastel pencils: white and very dark purple-grey

Charcoal pencil

Size 6 and size 2 colour shapers

1. Draw the scene with charcoal pencil.

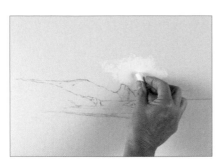

2. Paint the light part of the stormy sky, which will highlight the contrasting dark focal point, Ricket's Head, with pale Naples yellow.

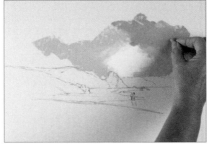

3. Use a red earth pastel around the Naples yellow, then paint dark cloud coming in from the right with pale purple-grey.

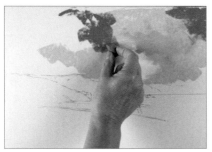

4. Around the edges of the cloud, use pale blue-grey, then on the right and left-hand sides, add dark purple-grey.

5. Modify the dark purple-grey with mid-toned purple-grey as shown.

6. Add a cooler colour on the left with blue-grey, then lighten some areas by adding white.

7. Blend the sky colours with your fingers. This picture shows the right-hand side done and the left-hand side still to do.

8. At this point I decided to add a little more dark purple-grey on the left, which I then blended in.

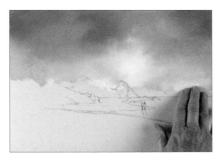

9. Use your fingers to bring the sky colours down over the tops of the far-distant hills on the right.

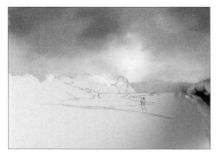

10. Use a pale blue-grey to describe the outline of the hills, using the whole length of the pastel on its side to create a broken line. Go down slightly over the horizon.

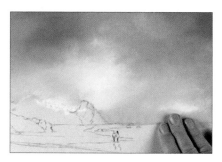

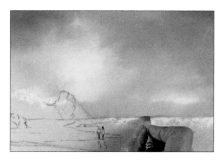

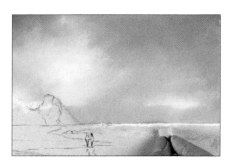

11. Add a little more white above the far-distant hills on the right, then clean your hand and use your fingers to sweep the sky down over the hills.

12. Establish the sea horizon using white pastel. Make sure you get it straight. Use the size 6 colour shaper to tidy the horizon and to remove any white that has gone over it.

13. Now paint the sea colour, pale blue-grey, up to the horizon, leaving a white line at the top. Soften the colours together with your finger.

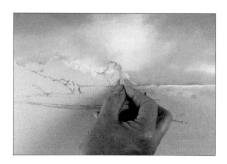

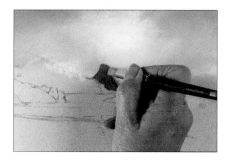

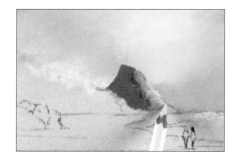

14. Paint the right-hand edge of the focal point, the headland, with white, then modify it with pale red-grey.

15. Use dark purple-grey to create texture on the light part of the rock, then very dark purple-grey for the crevice. Clarify and reshape the rock with the size 6 colour shaper.

16. Use a white pastel pencil to drag the pale colour of the rock over the mid-tone.

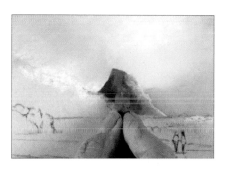

17. Add shadow at the left-hand side of the rock and at the base with very dark purple-grey.

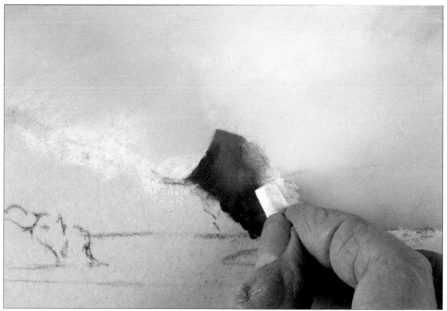

18. Sweep white pastel from the right to the left-hand side of the rock.

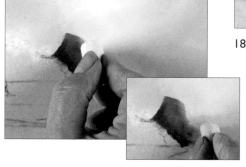

19. In steps 17 and 18 the shape of the rock was lost by clumsy application of the white pastel. To correct this I cut back in around the rock with the colours used in the sky to reshape the rock to its original shape.

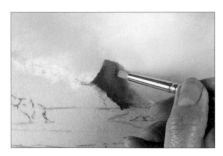

20. Repaint the crevice with very dark purple-grey and soften the right-hand edge with the size 2 colour shaper.

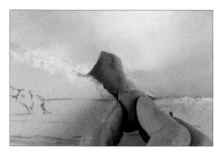

21. Darken the base of the rock with dark purple-grey so that the lighter water will contrast with it. Use the colour shaper to blend the dark base in with the lighter rock areas.

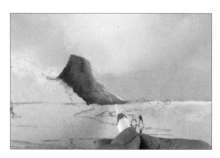

22. Use a white pastel pencil to place highlights on the rock.

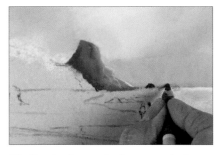

23. Put in the small, distant rocks in the sea with a very dark purple-grey pastel pencil.

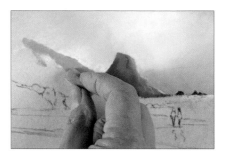

24. Use a purple-grey pastel to describe the edge of the cliff.

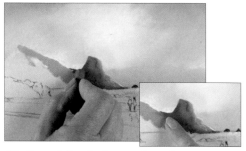

25. Extend the shadow in the col between the rock and the cliff with very dark purple-grey. Blend with your finger.

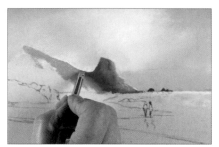

26. Use a size 2 colour shaper to blend the delicate area at the edge of the shadow.

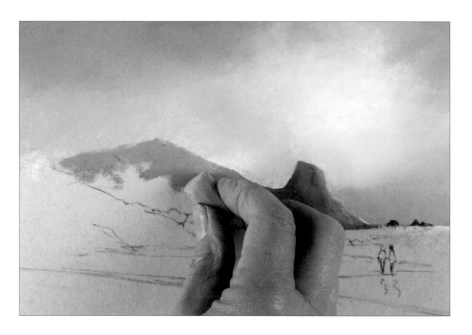

27. Paint the next area to the left with blue-grey.

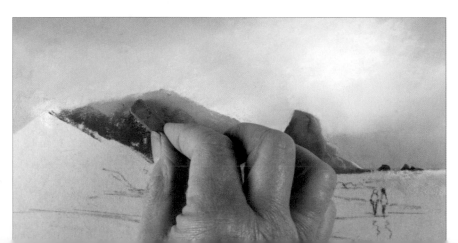

28. Use very dark purple-grey to the left of this, sweeping it in an arc from left to right. Blend the dark into the lighter area by making directional strokes with your fingers.

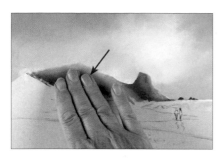

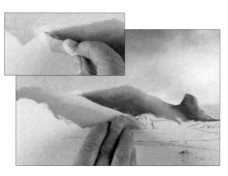

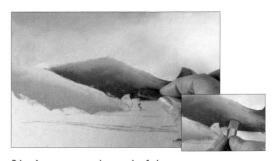

29. Clean your hands thoroughly, then use your fingers to sweep the sky down over the cliff to soften it. Fading off this area a little will draw attention to the sharper focal point.

30. You need warmer colours coming further forwards to create a feeling of recession. Use pale sap green against the very dark purple-grey to begin creating the nearer headland, then add green-grey. Blend with your fingers.

31. Accentuate the end of the grassy headland by darkening the cliff behind it with very dark purple-grey. Blend and manipulate the pastel with the size 6 colour shaper to create rocky texture.

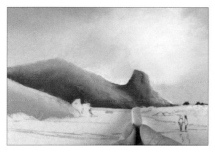

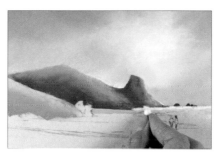

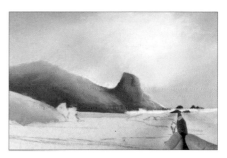

32. Begin to describe the distant sand at the base of the cliff with very pale pink pastel.

33. Continue the white water from the sea with circular motions of a white pastel to create surf, then add splashes.

34. Add some more small, distant rocks in front of the foam with very dark purple-grey pastel pencil.

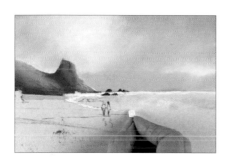

35. Use the white pastel to create the surf of the tideline, going behind the figures.

36. Paint the water over the sand with turquoise, then add dark blue-grey to the right.

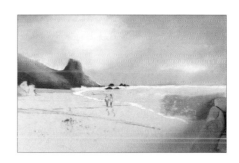

Tip

To add texture, skate one colour over another using the long edge of the pastel stick. The lighter the pressure, the more broken the colour will be.

37. Blend the sea colours together with your fingers, then add a little texture with pale blue-grey, skating the light colour over the darker ones.

53

38. Use very pale burnt sienna to paint the distant sand.

39. Paint the crevices in the rocks at the end of the green headland with very dark purple-grey.

40. Put in the lighter parts of these rocks with green-grey, then add warmth with red-grey. Blend with the size 2 colour shaper to create a more rocky look, leaving some paper showing for highlights.

41. Use a white pastel to improve the tide line and to add touches of surf to the water.

42. Texture the sand around the figures with pale Naples yellow.

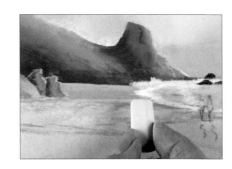

43. Put in the simplified, silhouetted figures with charcoal pencil. They should be little more than carrot shapes with dots on top.

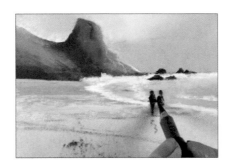

Tip

Take the opportunity to sketch figures in the margin of your sketchbook when you spot them. You can then place them in the best position in your painting.

44. Paint the base of the green headland with very dark green-grey, and blend into the lighter green with your fingers.

45. Use broad strokes of a dark purple-brown to warm the base of the headland, then use the pastel's shape to create dark crevices towards the right-hand side. Blend these outwards with the size 2 colour shaper.

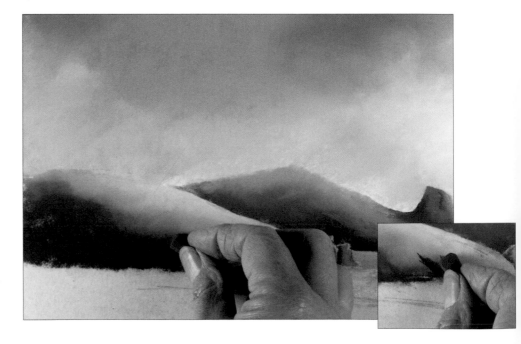

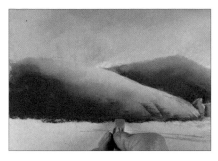

46. At the very base of the headland, paint a line of very dark purple-grey, then use the size 6 colour shaper to blend this up into the other colours.

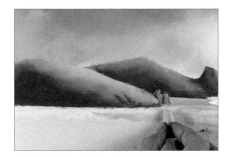

47. Use pale Naples yellow to paint the sand along the base of the headland, then add touches of very pale burnt sienna.

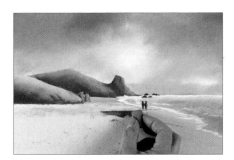

48. Now work on the reflection in the wet sand. Start with the darkest part of the headland, and use very dark purple-grey to paint its reflection, then add medium purple-grey.

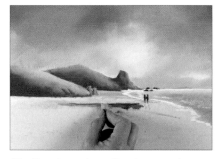

49. Continue the reflections to the left with very dark green-grey, then add green-grey, reflecting the colours above.

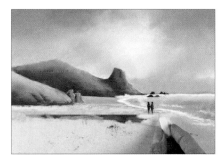

50. Add purple-brown to the left-hand side of the reflections, then paint pale Naples yellow below the figures, as a reflection of the lightest part of the sky.

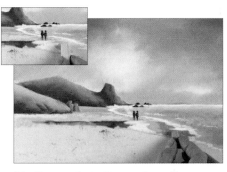

51. Paint pale pink into the reflection, and then purple-grey up to the white of the tide line.

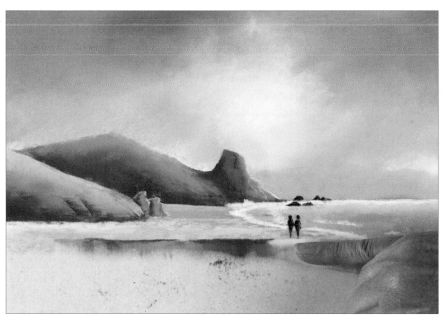

52. Clean your hands and then use a finger to drag the reflection colours together vertically.

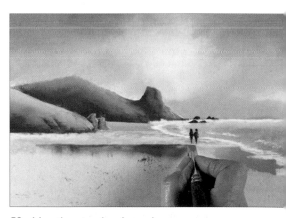

53. Use the size 6 colour shaper to straighten the top edge of the wet, reflective area of sand, using horizontal strokes.

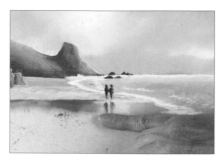

54. Draw two wiggly lines with charcoal pencil for the reflections of the figures, then smudge them with a vertical sweep of a clean finger.

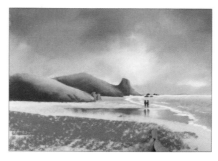

55. Sweep burnt sienna across the foreground as an undercolour.

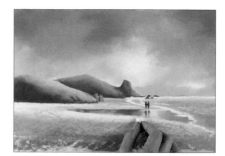

56. Apply pale burnt sienna on top, then pale Naples yellow round the edge of the reflections.

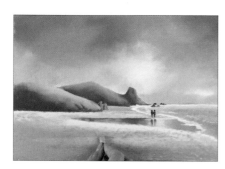

57. Tone down the brightness of the foreground with red-grey.

58. Extend the left-hand side of the reflection with very dark green-grey.

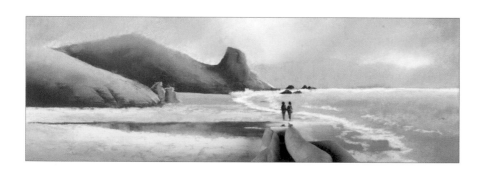

59. Paint some ripples of white within the reflection area for surf, then use the sharp edge of the white pastel to create a ripple through the reflection of the figures. Refine the line with a colour shaper.

60. Use very dark red-grey from the bottom left of the painting towards the centre. Soften with your fingers.

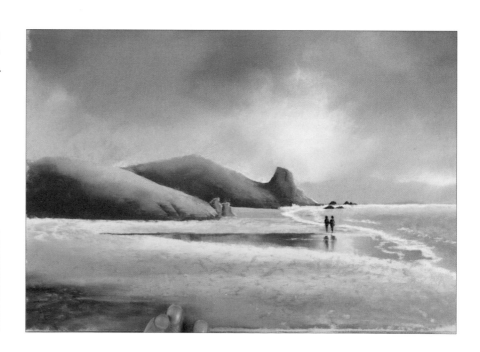

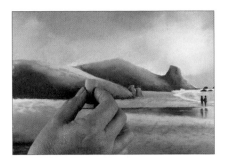

61. Add flecks of sap green to the headland to brighten it, and soften these in with your fingers and a colour shaper.

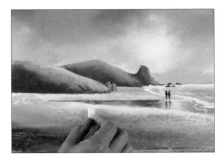

62. Sweep pale Naples yellow across the beach.

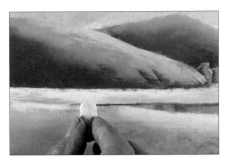

63. Use red-grey to create the gulley that water is running out of onto the beach. Emphasise this by using pale Naples yellow underneath for contrast. Soften with your fingers.

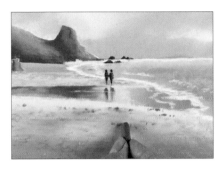

64. Use very dark purple grey to stipple stones in the foreground.

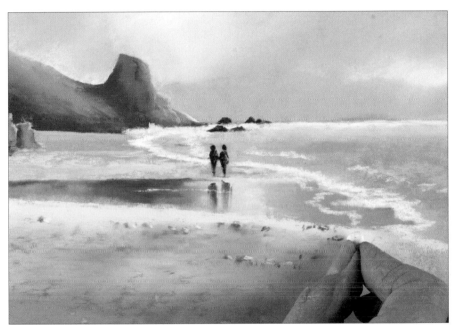

65. Add little white ticks to some of the stones to describe the light catching them.

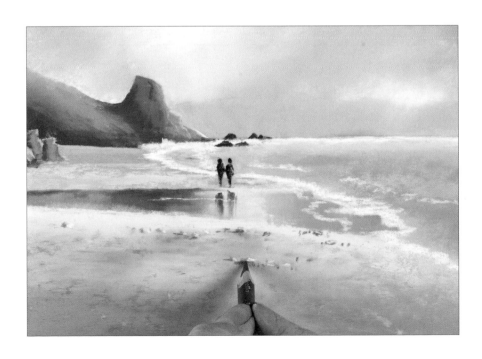

Tip

Do not overdo detail in the foreground as it can detract from the focal point. Just a few stones or pebbles will suffice.

66. Finally add cast shadows to the left of the stones with very dark purple-grey pastel pencil.

57

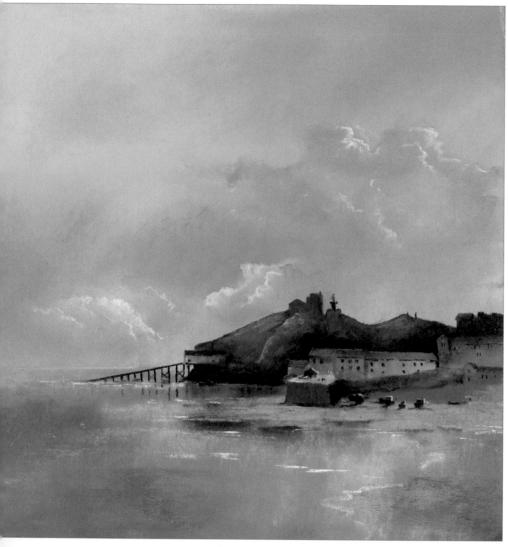

Sunset Over Tenby Harbour

22 x 23cm (8⅝ x 9in)

The challenge of painting a sunset is to keep any dark features in the painting very simple, as the fading light obscures much of the detail. A simple silhouette is often not sufficient so the secret is to subdue the features that are in shadow.

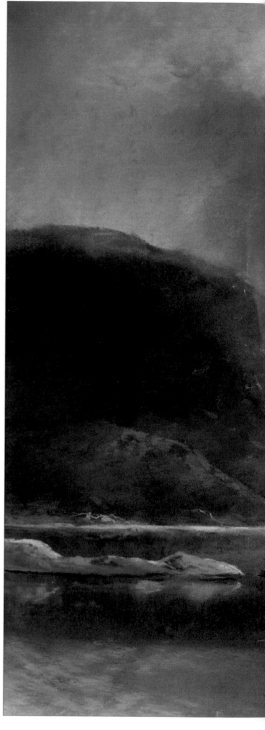

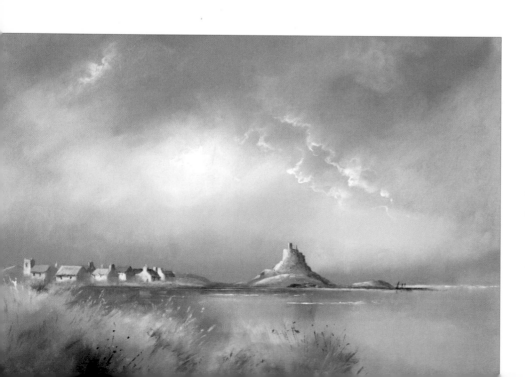

Lindisfarne

33 x 23cm (13 x 9in)

A romantic interpretation of a special place. The enchanting tales associated with this place called for an atmospheric mood to create an ethereal feeling. This was achieved by reducing the detail and using high key tones.

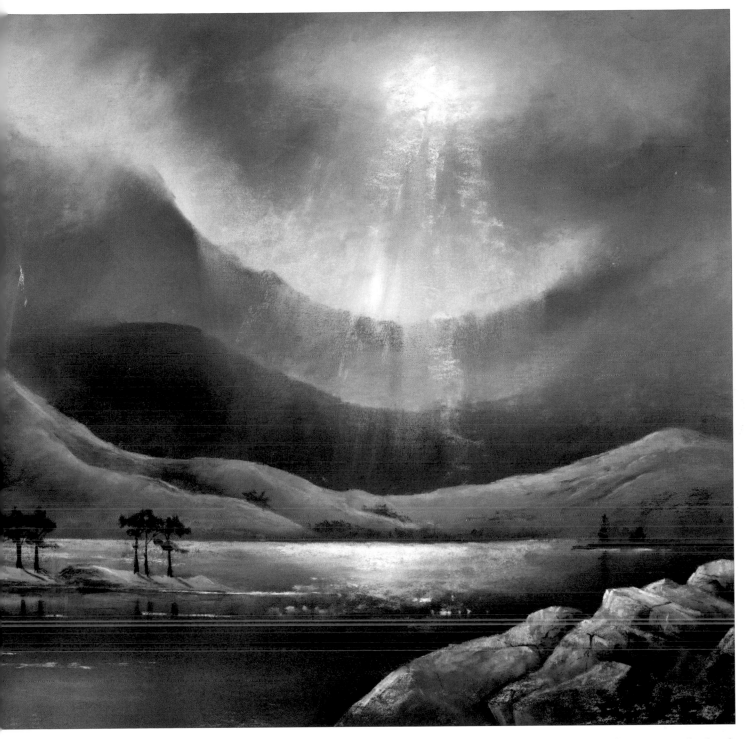

Storm over the Loch

34 x 24cm (13³/₈ x 9¹/₂in)

Now and then it is great to go 'over the top' with colour and tone to create a dramatic effect. This painting may seem to be taking this philosophy to the extreme but I can assure you that it is not an exaggeration of the atmosphere that I observed on this occasion. The shafts of sunlight breaking through the cloud were painted using gentle sweeps of white pastel in a downward direction, softening edges here and there.

Harbour Scene

COLOUR AND TONE

Plockton in Scotland is one of those inspirational places, where the light is always exciting, changing the mood from one extreme to another in a few minutes. The photograph I took of the scene shows the background cliffs dark and foreboding, with no detail, but I have sketched this same scene on two different occasions and I decided to use the atmosphere when a sea mist was starting to drift in, softening the background cliffs to a pale tone.

In this painting I have used complementary colours such as orange and purple to create impact but at the same time the pale, cool tones in the background create a mysterious atmosphere.

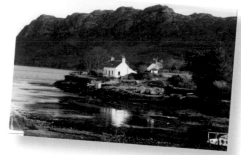

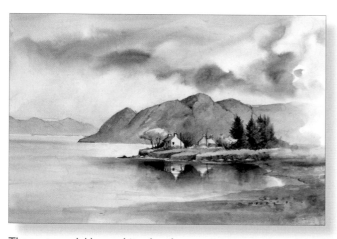

The water-soluble graphite sketch.

A tinted charcoal sketch to capture the colour.

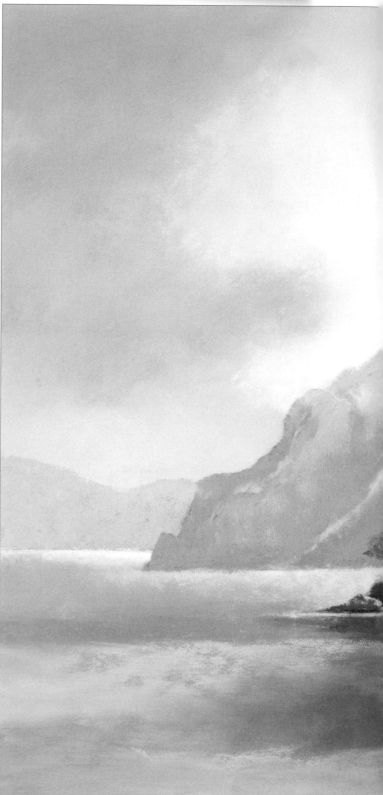

60

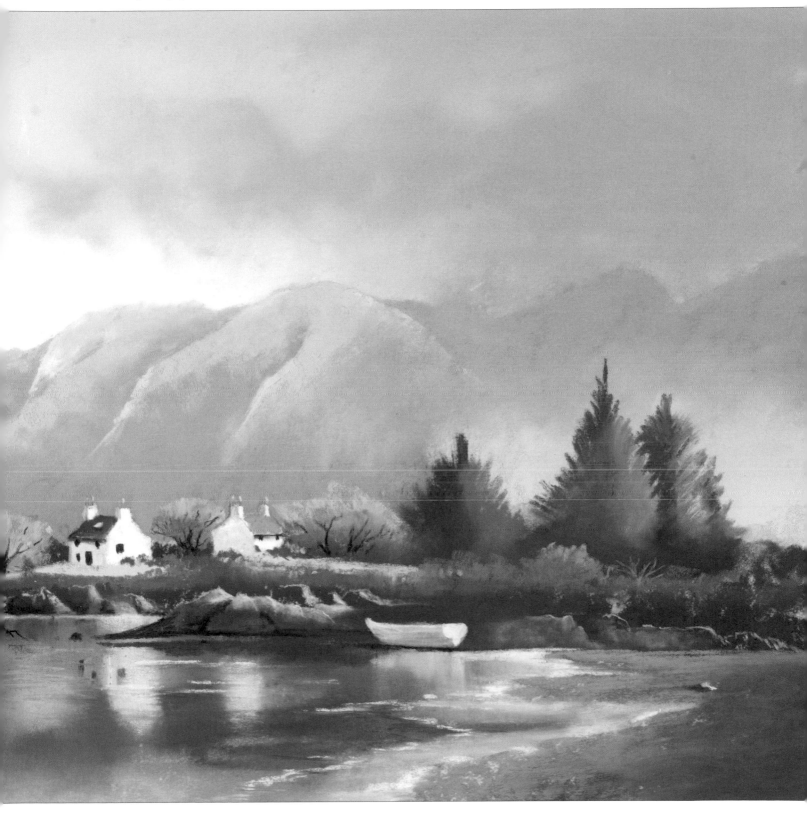

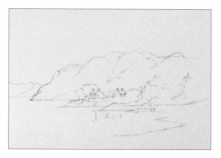

1. Draw the scene with charcoal pencil.

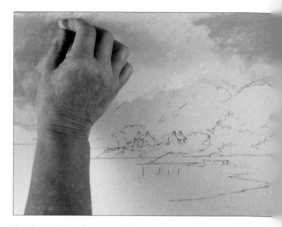

2. Paint the sky over the crags, working outwards from the centre, with first white, then very pale blue-grey, then blue-grey, and finally dark blue-grey. Blend with your fingers.

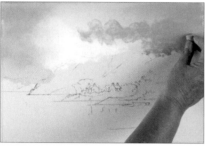

3. Add extra clouds on the right, down towards the crags, with dark blue-grey, and blend with your fingers.

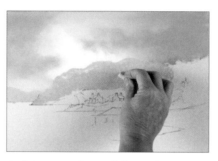

4. Paint very distant hills on the left-hand horizon with pale purple-grey, then outline the crags, using the full length of the pastel.

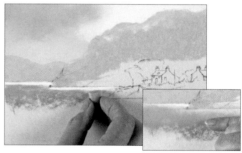

5. Paint white at the top of the sea, then green blue-grey lower down, and blend together.

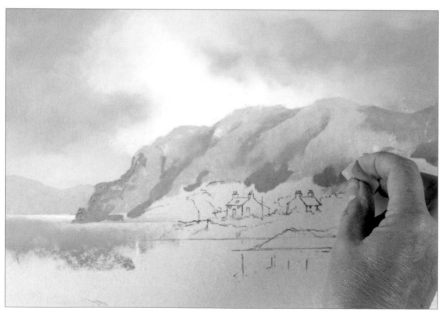

6. Create shadow, gullies and crevices in the crags with dark blue-grey. Blend and shape with a size 6 colour shaper and your fingers.

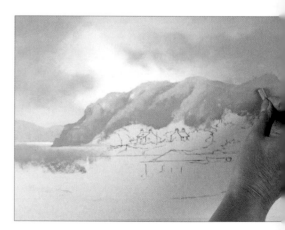

7. Add texture here and there on the crags with purple-grey.

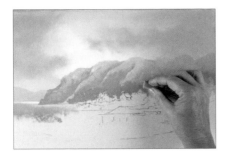

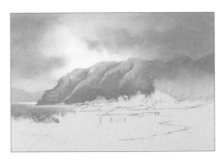

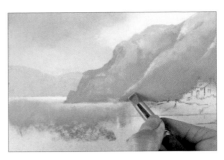

8. Use dark blue-grey at the base of the crags, down behind the trees and buildings.

9. Add blue-grey on the right, as a light background for the dark fir trees, and blend with your fingers.

10. Paint just above the tide-line on the crags with dark blue-grey and blend with the colour shaper.

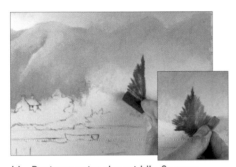

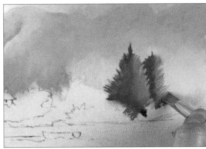

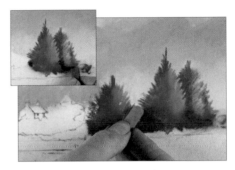

11. Begin to paint the middle fir tree with dark green-grey, used vertically for the trunk, then at various angles for branches. Paint the right-hand side with green-grey.

12. Paint the next tree on the right, creating the edges of the first tree through negative painting. Paint the right-hand side with green-grey and use the colour shaper to create branches.

13. Darken the undersides of the trees with dark green-grey. Blend it in and add dark purple-grey. Paint the fir on the left in the same way and use the same colours at the base to join the three.

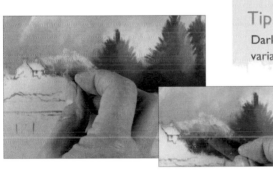

> Tip
> Dark purple-grey is good for portraying foliage in shadow to provide some variation from dark green.

14. Begin to paint the autumn trees to the left of the firs with Naples yellow, touching the pastel lightly to the paper to create the broken effect of foliage. Add burnt sienna lower down, then dark purple-grey at the base.

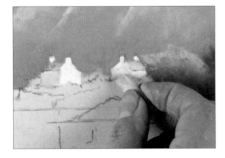

15. Paint both the cottages with white, then paint their shaded sides with pale blue-grey.

16. Shade the dark side of the left-hand cottage's roof with dark purple-grey, then paint the lighter side of the right-hand roof with purple-grey.

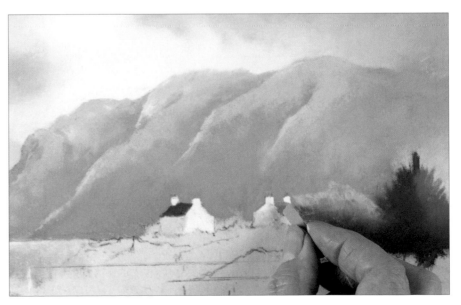

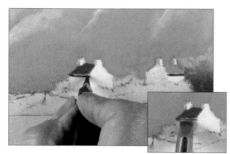

17. Paint the shaded sides of the chimneys with blue-grey pastel pencil, then under the eaves with dark purple-grey pastel pencil. Blend the shadows under the eaves downwards with the size 6 colour shaper.

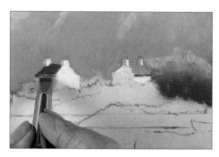

18. Add chimney pots with yellow ochre pastel pencil, then highlight the sides with white pastel pencil. Use this to add a rooflight in the left-hand roof.

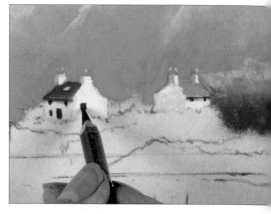

19. Use a charcoal pencil to put in the darkest details: the doors and windows.

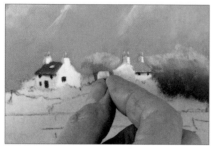

20. Paint the tree between the cottages with burnt sienna, then highlight it with Naples yellow.

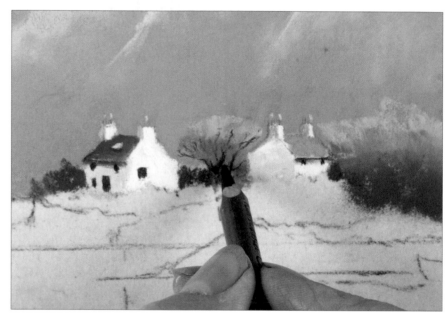

21. Define the edges of the buildings by adding low bushes in dark green-grey, then use a sharp charcoal pencil to paint the trunks and branches of the tree between them. Lose parts of the lines with a colour shaper to suggest foliage.

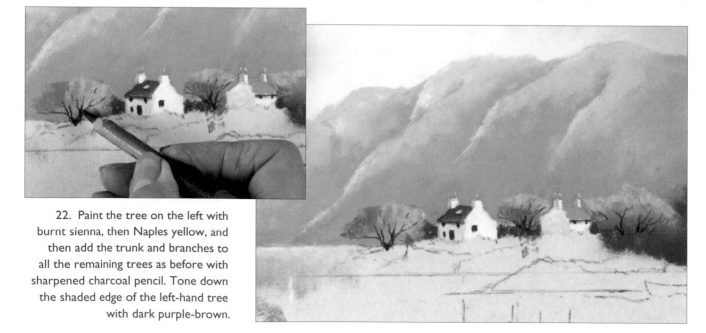

22. Paint the tree on the left with burnt sienna, then Naples yellow, and then add the trunk and branches to all the remaining trees as before with sharpened charcoal pencil. Tone down the shaded edge of the left-hand tree with dark purple-brown.

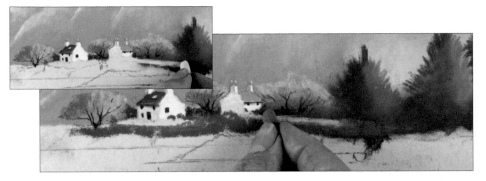

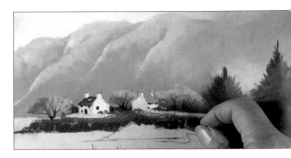

23. Use an acid green pastel to paint the bright grass in front of the buildings, then paint an autumn hedge right across the scene with a broken line of burnt sienna. Knock back the brightness of the hedge with red-grey. Add something growing up the right-hand cottage walls with the same colour

24. Dot Naples yellow along the hedge, then create the shore area below it with dark-purple grey.

25. Outline the shoreline rocks with white pastel pencil and pale grey pastel.

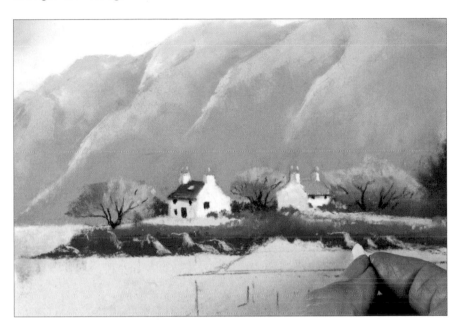

Tip

Try to make rocks different shapes and sizes so that they appear natural. Regular shapes and sizes convey manmade objects.

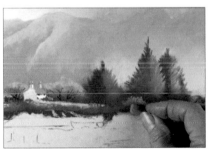

26. Brighten a tree growing from the hedge beneath the fir trees with orange pastel, and shade the left-hand side with burnt sienna.

27. Extend the rocky foreshore with dark purple-grey.

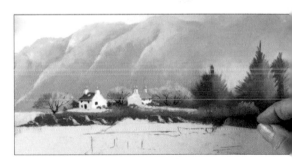

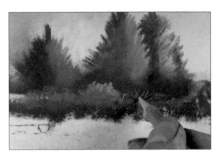

28. Use a yellow ochre pastel pencil to paint branches in the hedge.

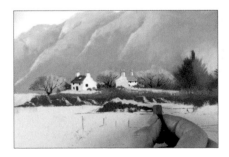

29. Paint the rocky headland in the middle distance with Naples yellow where it catches the light, then paint the lower part of it with green-grey, suggesting algae.

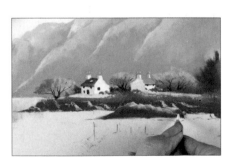

30. Add dark purple-grey lower down, then highlight with white pastel pencil.

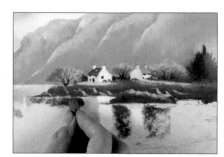

31. Begin to paint reflections with bands of white for the cottages, then blue-grey for their shadowed sides, then dark purple-grey for the rocky foreshore.

32. Paint the reflection of the rocky headland with green-grey, then fill in more of the water with green blue-grey.

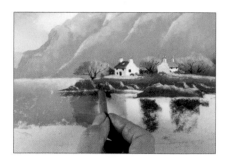

33. Use Naples yellow and burnt sienna to paint the reflection of the tree on the left.

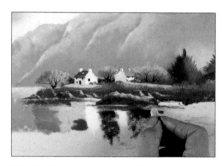

34. Add more dark purple-grey to the reflections, then add a hint of acid green to reflect the bright grass.

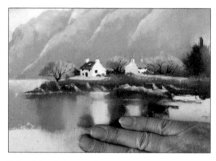

35. Blend the reflection in downward strokes with clean fingers.

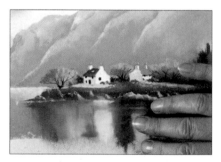

36. Add a further layer of colours to strenghten the reflections, then blend them again.

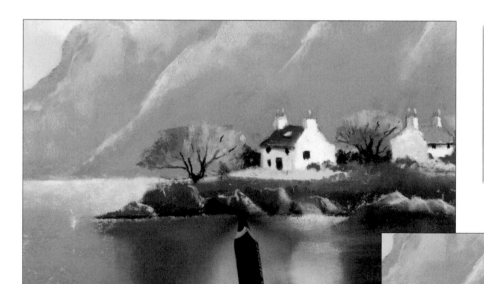

37. Use a dark purple-grey pastel pencil to paint the base of the rocks, then add a sliver of white pastel pencil to suggest a highlight on the water.

Tip

Reflections need to be built up in layers, as blending often softens the colours too much. Keep applying the colour and blending until you are satisfied. If you overdo it, brush away the pastel and start again.

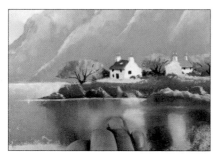

38. Paint reflections of individual rocks with dark purple-grey pastel, then soften these in a little with your fingers.

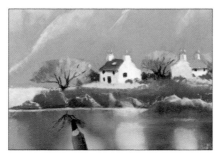

39. Use the charcoal pencil to draw in the reflections of trunks and branches.

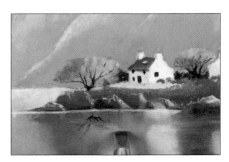

40. Suggest ripples with horizontal strokes of the size 6 colour shaper.

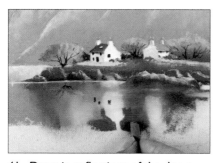

41. Draw in reflections of the doors and windows with the charcoal pencil, then use the dark purple-grey pastel to define the bottom of the reflection. Blend with your fingers.

42. Redefine the base of the rocky headland with dark purple-grey pastel pencil and add stray rocks.

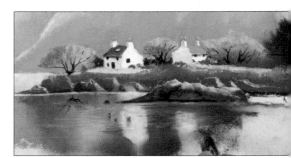

43. Create more ripples with horizontal strokes of the colour shaper.

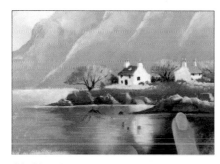

44. Use the colour shaper to bring the blue from the water over the reflection colours, then soften with your fingers.

45. Draw the rowing boat with white pastel pencil, then white pastel, then use a very pale grey pastel pencil on the shaded side to indicate planking.

46. Use a grey pastel pencil at the bottom of the boat and graduate it upwards.

47. Use a white hard pastel to create horizontal ripples.

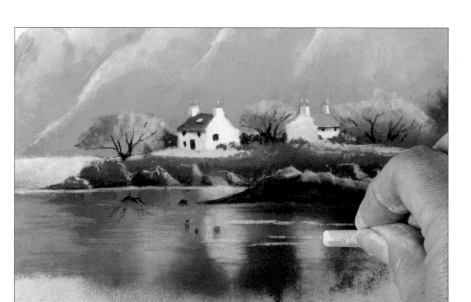

Tip

To get a clean, sharp edge along the length of the hard pastel stick, rub two sides of the stick on sandpaper until a corner forms.

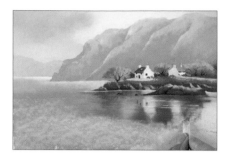

48. Paint green blue-grey in the water around the reflection, then go over it with pale blue-grey. Soften with your fingers, but leave some texture.

49. Redefine the boat by painting behind it with dark purple-grey, then use pale blue-grey to paint the tide line.

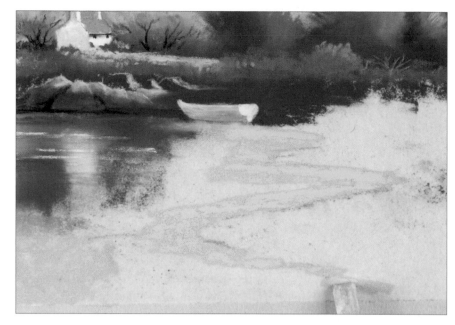

50. Paint just behind the tide line with dark green-grey, then dark purple-grey.

51. Darken the foreground water near the tide-line with green blue-grey, then blend this in to the other colours.

52. Paint the reflection of the boat with blue-grey pastel, then blend this with vertical strokes, gently so that the reflection does not spread too far.

53. Use the dark purple-grey pastel pencil to paint a line of shadow under the boat.

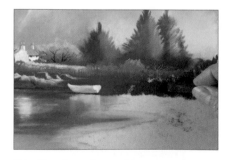

54. Continue the rocky area to the right of the boat with dark purple-grey and dark green-grey.

55. Hint at rocks with a very pale grey pastel pencil, but do not make the marks too strong, as they are not near the focal point.

56. Add warmth to the rocks with yellow ochre pastel, then knock this back with the colour shaper to suggest algae-covered rocks.

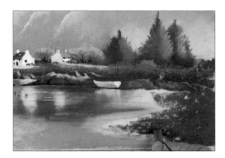

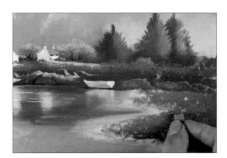

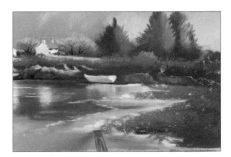

57. Work on the muddy foreshore by painting an undercoat of red-grey, then paint dark green-grey on top.

58. Warm the area with burnt sienna, leaving plenty of texture.

59. Add white to the tide line with a hit and miss technique, suggestion foam. Soften a little in places with a colour shaper and your fingers.

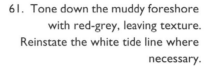

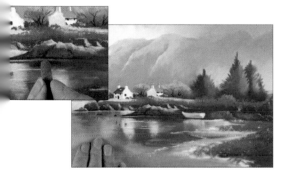

60. Paint a dark purple-grey reflection of the rocky foreshore. Soften the edge of the reflection area with vertical strokes of your fingers.

61. Tone down the muddy foreshore with red-grey, leaving texture. Reinstate the white tide line where necessary.

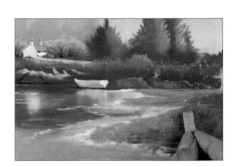

62. At this point I felt the reflection of the tree was too weak so I used dark purple-grey around the edge of the reflection to strengthen it, and softened this with my fingers

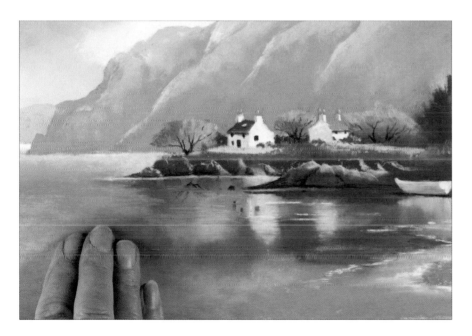

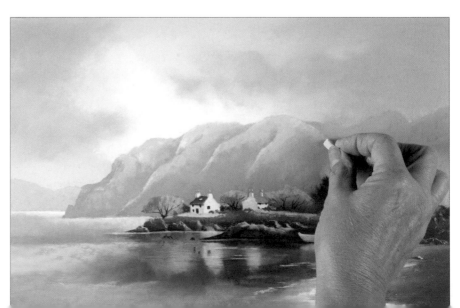

63. Create a sparkling, rippled area in the water with pale blue-grey.

Tip

Step back from your painting to view it from time to time as mistakes are often more apparent from a distance.

64. Finally, add highlights to the right-hand sides of the crags with pale blue-grey.

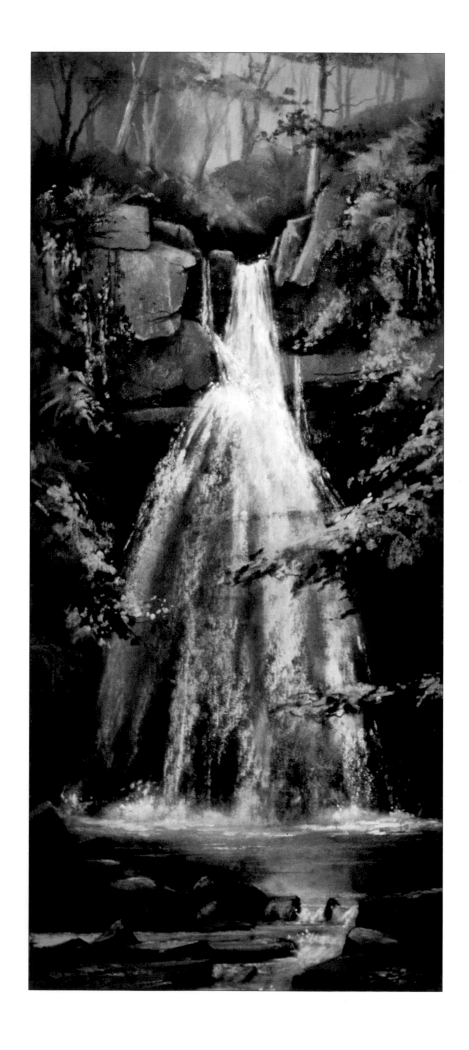

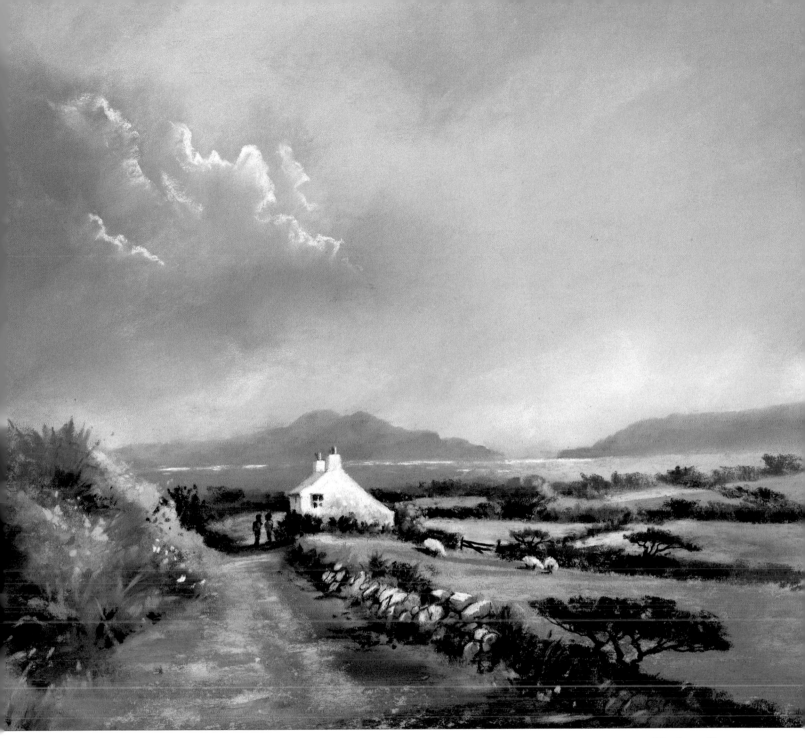

Trelwyn Farm
30 x 30cm (11¾ x 11¾in)

Colour and tone are the key in this painting. The cool blue of the distant islands compared to the warm greens and yellows in the fields around the building accentuate the feeling of distance. Darker tones in the hedgerows and around the building reinforce this effect. Notice how the hedgerows all converge on the cottage, leaving no doubt where the focal point is.

Opposite

Waterfall Near Talybont

18 x 45cm (7 x 17¾in)

The complementary colours of red and green are used in this painting to add harmony to the combination of rocks and foliage. There is ample drama in the contrast between the white water and the shadows under the rock overhang, and the bright yellow reflection in the pool at the base of the fall draws the eye down in the direction of the flow of the water.

Iris

COMPOSITION FOR FLOWER PAINTING

The flamboyant colour and shape of flowers, and the exciting way that light affects them is so stimulating to the senses that sometimes I just have to paint them. I am not a botanical artist and I do not try to be accurate in my portrayal of the blooms. My delight lies in the sheer exuberance and energy of plants.

This Siberian Iris emerges in my garden in late spring and the fresh green foliage of nearby plants provides a perfect complementary colour for the strong purple petals.

A muted background allows the iris to be the centre of attention and other buds, stems and leaves are suggested rather than painted in detail.

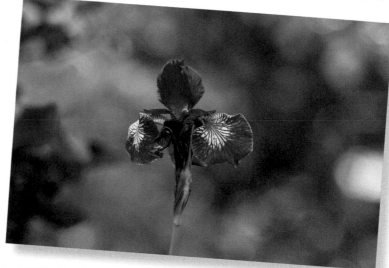

The reference photograph.

The pencil sketch.

Opposite

The finished painting.

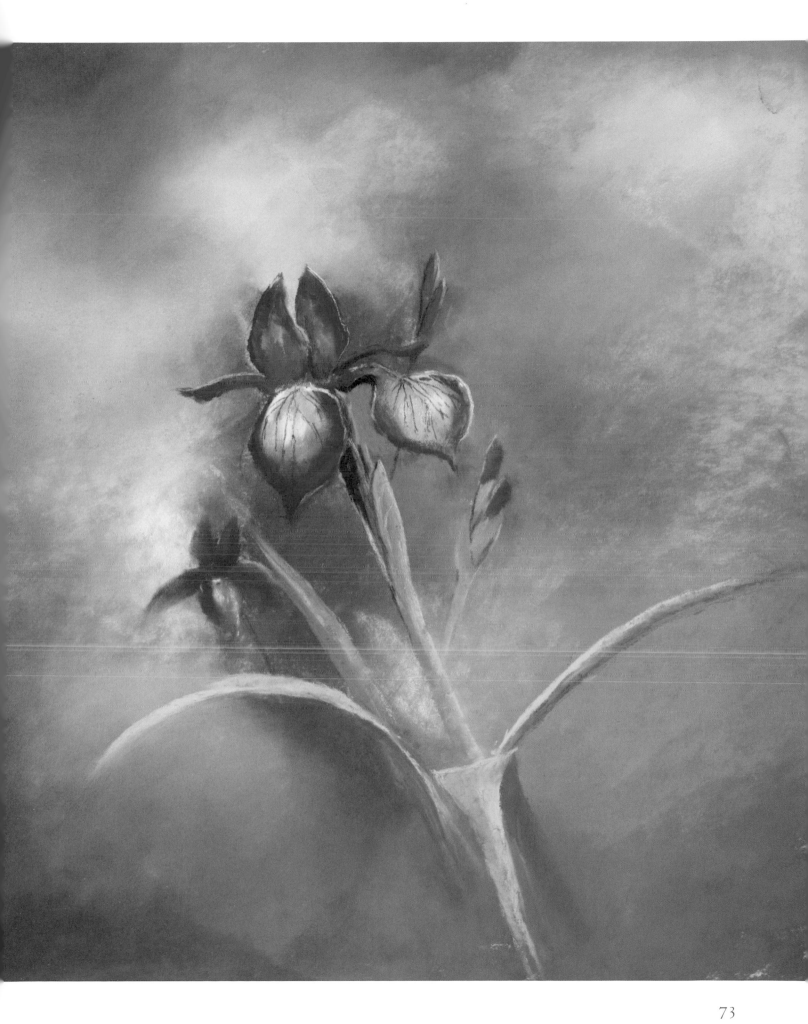

You will need

Artist grade sandpaper, 36 x 26cm (14¼ x 10¼ in)

Pastels: pale lizard green, green-grey, lemon yellow, pale red-grey, red-grey, dark green-grey, dark purple, dark French ultramarine, pale green-grey, dark purple-grey, purple, pale purple, white, fuchsia pink, French ultramarine, yellow ochre, sap green, burnt sienna, medium sap green, blue-grey

Pastel pencils: white, dark purple-grey, dark purple, yellow ochre

Charcoal pencil

Size 6 colour shaper

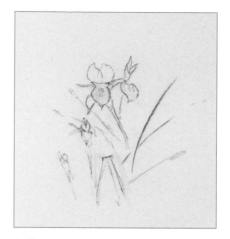

1. Draw the scene with charcoal pencil.

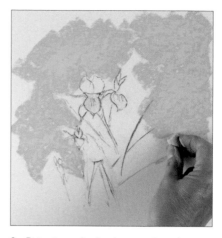

2. Paint into the background as shown with pale lizard green.

3. Add darker patches to the background with green-grey.

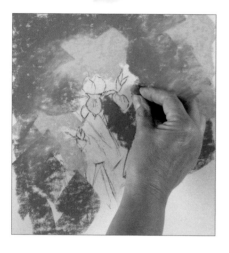

4. The iris will be purple, so use lemon yellow around some of its edges to complement it.

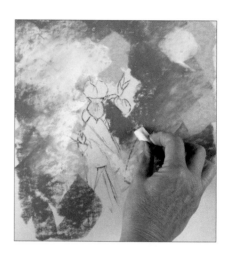

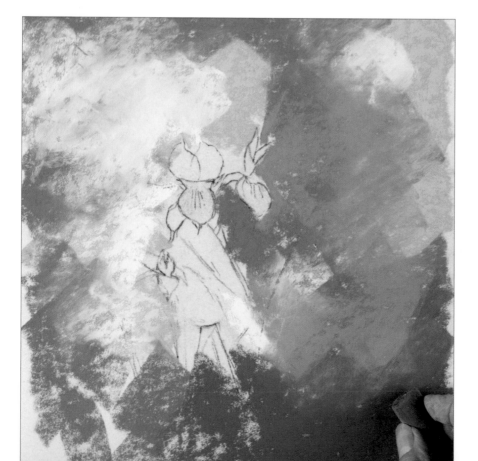

Tip

Combining colours in the background suggests distant foliage in sunshine. Lots of detailed foliage tends to compete with the focal point. Use colour instead of detail to suggest features.

5. Apply some pale red-grey in the background. This will echo one of the colours in the folded leaf casing. Add red-grey at the bottom right.

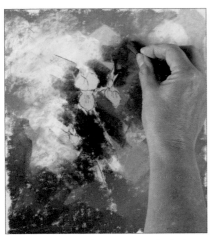

6. Introduce darker tones with dark green-grey.

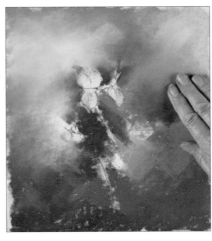

7. Blend the backround with your fingers, using a circular motion.

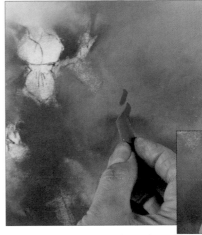

8. Paint the buds on the right with dark purple, then add dark French ultramarine on top.

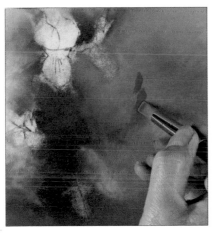

9. Use the size 6 colour shaper to create a point at the top of each bud, suggesting folded petals.

10. Begin to paint the petal casing with pale green-grey.

11. Go over this with pale red-grey.

12. Add shadow with dark purple-grey.

13. Use burnt sienna to paint the bud casing.

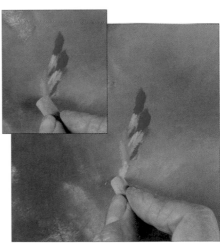

14. Continue painting the bud casing with pale red-grey then pale green-grey.

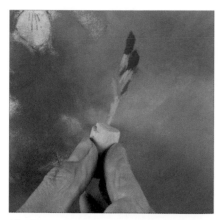

15. Paint the stem with the buds on it with pale lizard green, using the long edge of the pastel stick.

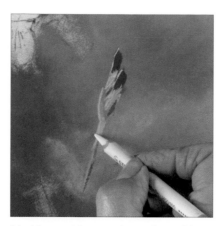

16. Use a white pastel pencil to add highlights and create structure.

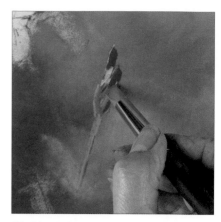

17. Blend the colours a little with the size 6 colour shaper.

18. Use a yellow ochre pastel pencil to make the bud casing look papery.

19. The bud needs to look more distant than other parts of the plant, so soften it a little by just pressing it gently with your fingers.

20. Reshape the bud with the colour shaper by tidying the green behind it.

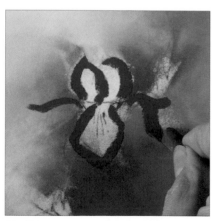

21. Begin to paint the main bloom with purple pastel.

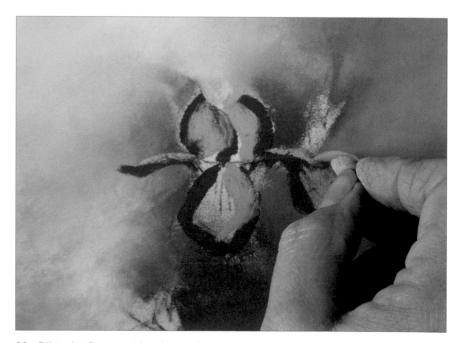

22. Fill in the flower with pale purple.

76

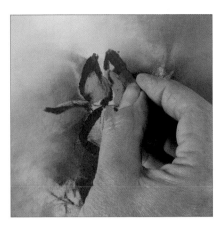

23. At this point I felt that the tops of the iris needed to be higher, so I added more height with purple.

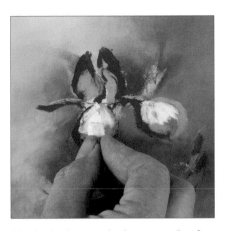

24. Add white to the lower petals of the iris as shown.

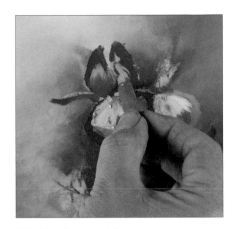

25. Use fuchsia pink to suggest light shining through the petals.

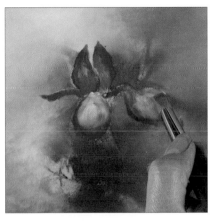

26. Use the size 6 colour shaper to sharpen up the edges and to pull the colours smoothly together, creating form.

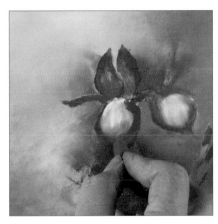

27. Add more white to create a good background for the veining to come. Paint more French ultramarine around the edges.

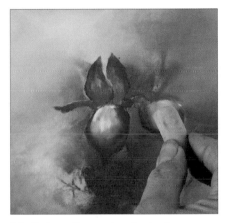

28. Paint yellow ochre in the lower petals of the iris.

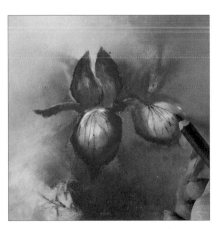

29. Use a very sharp dark purple-grey pastel pencil for the veining.

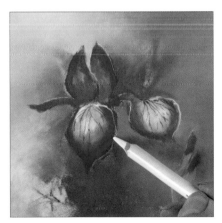

30. Change to a white pastel pencil to create highlights to help describe the shape of the petals.

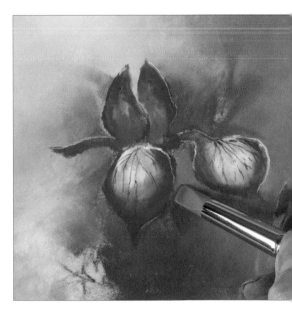

31. Use the size 6 colour shaper to smooth together the colours and tone down some of the highlights.

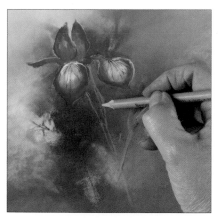

32. Draw the various stems of the flower with yellow ochre pastel pencil.

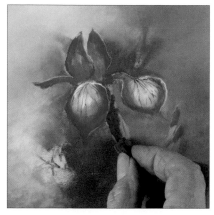

33. Shade the part of the stem under the petal with dark purple-grey pastel.

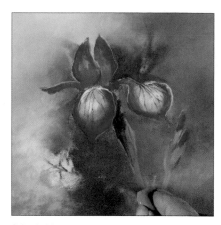

34. Add sap green to the stem.

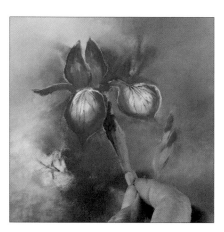

35. Add burnt sienna pastel to the structure on the stem from which the flower emerges.

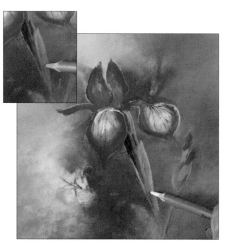

36. Add detail to this structure with yellow ochre pastel pencil, then use white pastel pencil to help create a three-dimensional appearance.

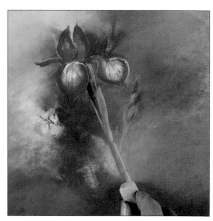

37. Continue the stem with medium sap green pastel. Add pale lizard green on the right for highlight. Use a colour shaper to blend together the stem colours, using a sideways stroke to suggest the cylindrical nature of the stem.

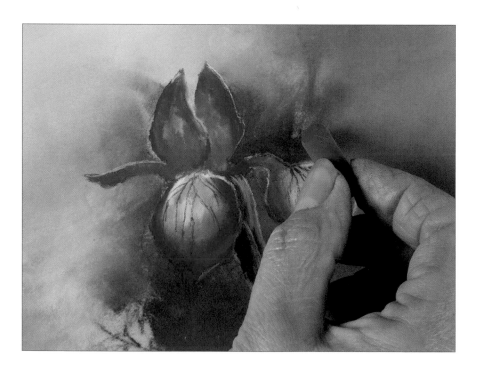

38. Use dark purple to add a small petal on the right.

78

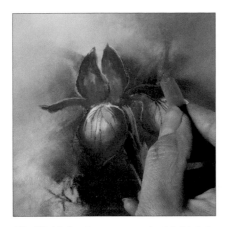

39. Highlight the new petal with fuchsia pink pastel.

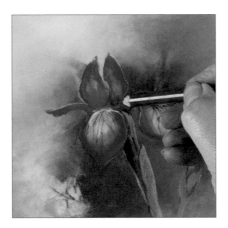

40. Add structure to the flower and stem with dark purple pastel pencil.

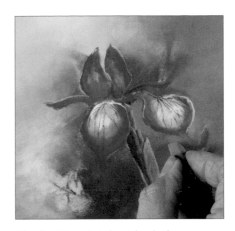

41. At this point, I cut back the shape of the right-hand petal with green-grey pastel.

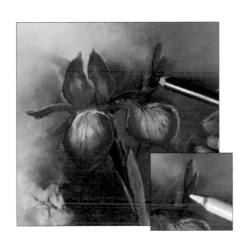

42. Suggest the silhouette of a more distant bud with dark purple-grey pastel, then darken the left-hand side with dark purple-grey pastel pencil. Highlight the right-hand side with white pastel pencil.

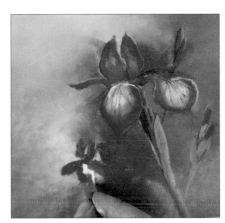

43. Paint in the distant bloom with dark purple pastel, then white for the throat, then fuchsia pink as before, but with less detail.

44. Use the colour shaper to blend the colours of this bloom together. Then use your fingers to soften the edges by blending the background over them.

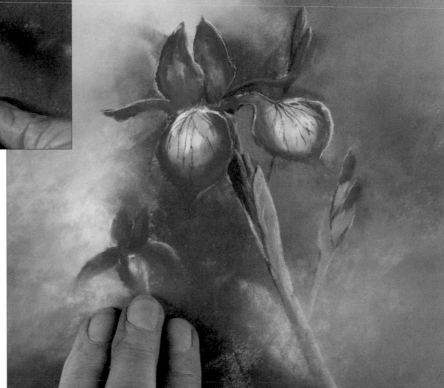

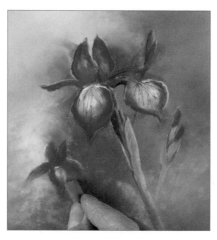

45. Add a glaze of blue-grey over the white of the right-hand petal to suggest shadow. Reinstate the veining afterwards with charcoal pencil and the tip with dark purple pastel.

46. Hint at a stem for the distant flower with dark green-grey.

47. Paint in a leaf with pale lizard green, then shade the underside with sap green.

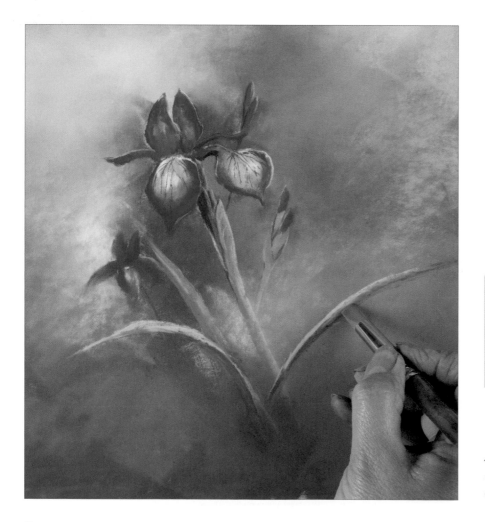

Tip

To keep the attention on the main flower head, fade out the detail of stem and leaves at the margins of the painting. Use the shapes to draw the eye upward towards the central bloom.

48. Add the other upright leaves, and blend the colours with the colour shaper.

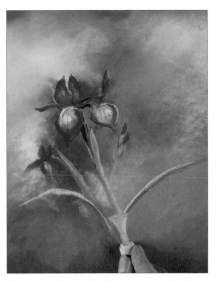

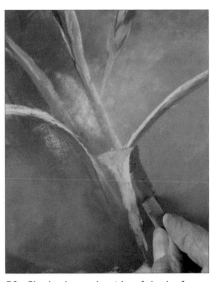

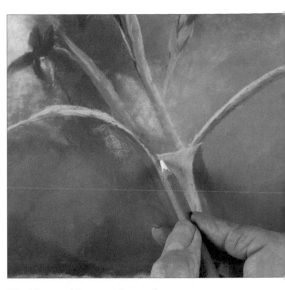

49. Paint the leaf bending towards the viewer with yellow ochre, then with pale lizard green lower down.

50. Shade the underside of the leaf with dark green-grey. Blend with the colour shaper.

51. Use a white pastel pencil to highlight the top edge of the leaf.

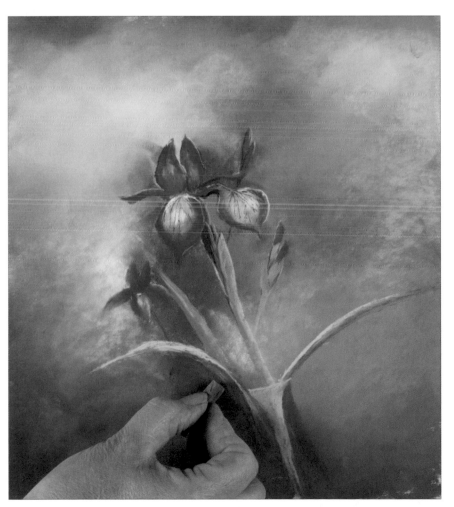

52. Use dark green-grey on the background to smooth and clarify the edge of the left-hand leaf.

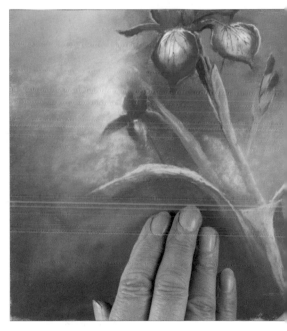

53. Blend this darkened area. At this point I decided to add more of the same dark green-grey to the left-hand side of the painting, coming down from the top. This helped to frame the scene.

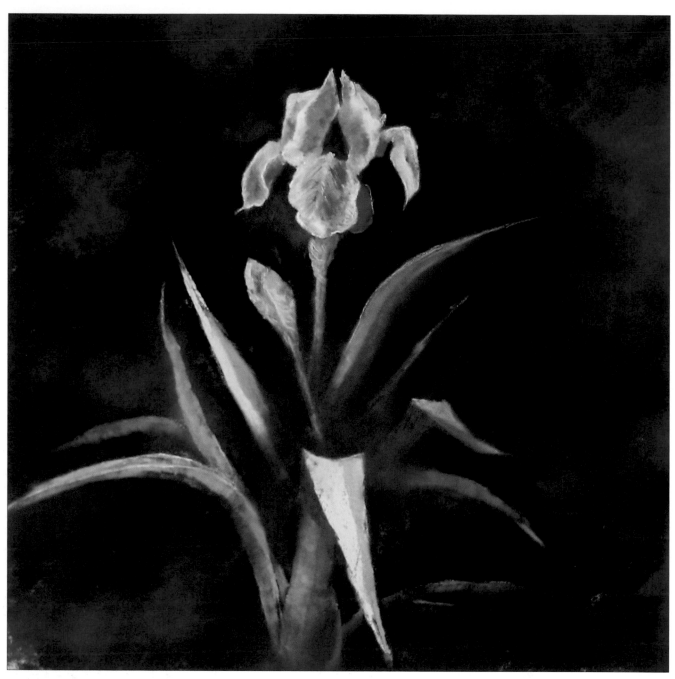

Bearded Iris

23 x 23cm (9 x 9in)

Capturing the delicate detail of petals is a challenge. For this painting I covered the
whole background with midnight blue pastel with a few touches of dark burgundy,
blended it all together and then sprayed the whole thing with fixative and left it to dry
thoroughly so that when I began on the flower head, none of the background colour
lifted off. This allowed me to draw the outline in white pastel pencil and create the fine
detail. Allowing some of the leaves to disappear into the dark enhances the drama.

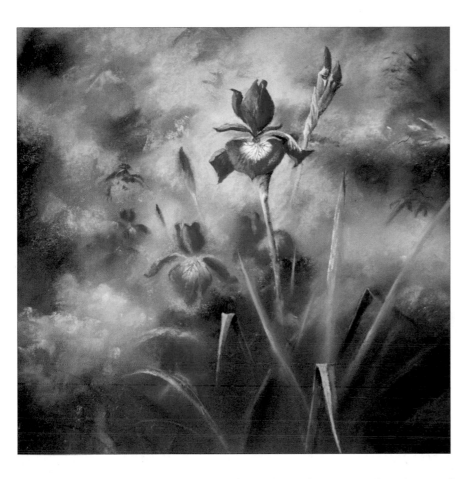

Siberian Iris

30 x 30cm (11¾ x 11¾in)

To draw attention to the main flower head, I have softened the rest of the blooms and overlapped them with stems. The background is kept abstract with just a suggestion of leaves and yellow foliage to provide a complementary colour for the irises.

Yellow Rose

25 x 25cm (9¾ x 9¾in)

This yellow climbing rose is a long-term resident of my garden. I love the blooms at all their stages – the tight buds, the emerging flower and the overblown blooms all delight me. Capturing the bulbous shape at the base of the emerging bud without using any blue for the shadow areas creates a challenge. A darker tone of the same colour works best for the shadow areas of yellow flowers. Adding blue shadows modifies the colour too much.

Farm in a Landscape

AERIAL PERSPECTIVE

The use of colour, tone and detail to portray aerial perspective or recession has been discussed throughout this book. It can hardly be emphasised enough as the basis for successful landscape painting. In this final demonstration of a scene in West Wales, all the techniques used in the previous landscape demonstrations are employed to reinforce the message.

The light on the landscape is the vital element, and cloud shadows that drift across the fields, highlighting some features and darkening others, give us the opportunity of manipulating the light to emphasise our focal point and to hide things we want to leave out.

The photograph of Clegyr Boia, the crag in the background, shows how blue distant features are, but there is also a patch of dark green in the distant left-hand side which does not suit my composition. The building is an interesting shape but it is dull and almost disappears into the background. In my watercolour sketch, I have made the fields lighter and the cottage darker to make it stand out, but in this demonstration I have decided to make the cottage white. Cool colours in the distance, little detail in the middle distance and warm colours in the foreground have all been used once again to create the impression of space.

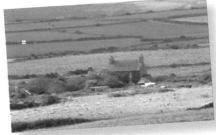

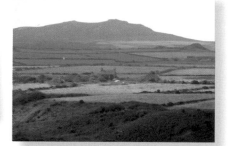

The reference photographs.

The watercolour sketch.

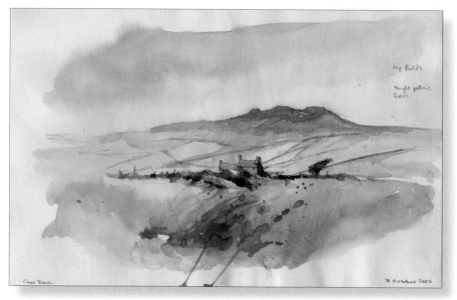

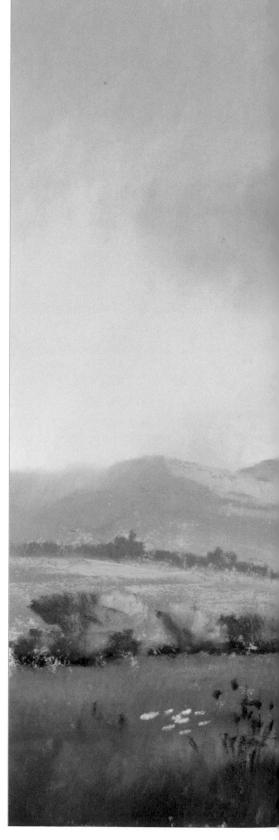

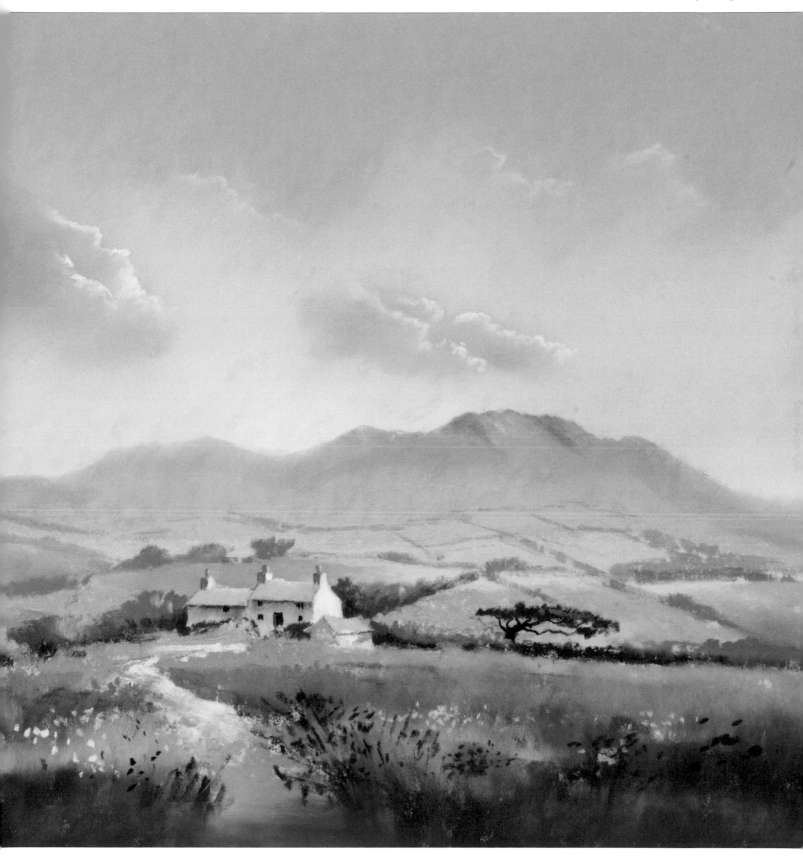

You will need

Artist grade sandpaper, 36 x 26cm (14¼ x 10¼ in)

Pastels: Naples yellow, pale poppy red, very pale cobalt blue, cobalt blue, dark cobalt blue, purple-grey, white, green-grey, dark purple-grey, sap green, lizard green, dark Naples yellow, yellow ochre, red-grey, dark green-grey, blue-grey, pale purple-grey, pale blue-grey, very pale blue-grey, olive green, very dark purple-grey, pale burnt sienna, burnt sienna, dark grey, pale Naples yellow

Charcoal pencil

Pastel pencils: dark grey, white, grey

Size 6 and size 2 colour shapers

1. Draw the scene with charcoal pencil.

2. Paint the glow in the lower sky with Naples yellow near the horizon. You can go over the drawing.

3. Use pale poppy red to add a pinkish glow to the lower sky, then paint around this with very pale cobalt blue.

4. Paint cobalt blue above this, across the whole sky, then take dark cobalt blue and paint this at the top of the sky.

5. Blend the sky colours with your fingers.

6. Paint a scudding cloud with purple-grey, and soften it with your fingers, then add highlights on the right-hand side with white pastel and soften the left-hand edge of them.

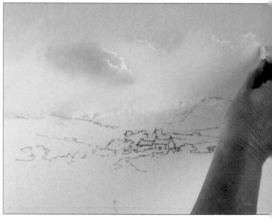

7. Suggest distant clouds by highlighting their right-hand edges in the same way.

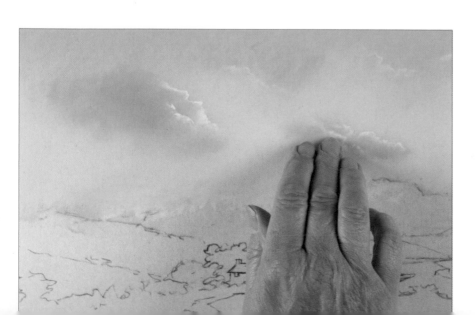

Tip

When blending large areas with your fingertips on sandpaper, make sure you have applied enough pastel to fill the grain, otherwise you will have sore fingers.

8. Create another smaller cloud on the right in the same way.

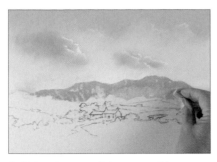

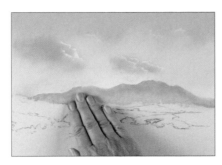

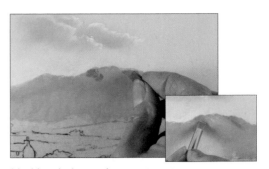

9. Paint the top of the crag with purple-grey, as for the clouds, then lower down paint green-grey.

10. Blend parts of the crags with your fingers, but do not lose all the texture. Clean your hands, and on the left-hand side, sweep the sky colours down over the crags to create a feeling of distance.

11. Use dark purple-grey to paint shaded areas in the highest crags, then tweak the shapes with the size 6 colour shaper.

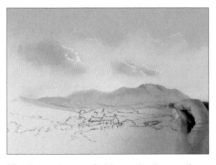

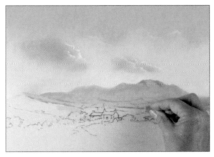

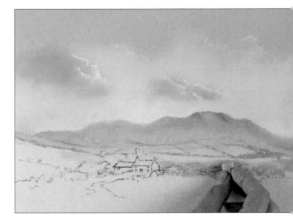

12. Paint distant fields at the base of the mountains with sap green, then paint hedgerows to divide them by just touching in lines of green-grey.

13. Use lizard green for the fields in front of these, then add hedgerows with green-grey, making larger marks this time.

14. Paint fields further forwards with dark Naples yellow, and in front of these use yellow ochre.

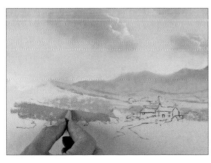

15. Use red-grey to paint a ploughed field on the far left.

Tip
Keep the margins of the painting simple so that the eye is not drawn away from the centre of interest.

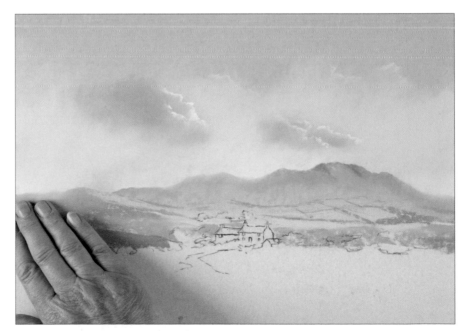

16. Enhance the left-hand edge of the mountains with purple-grey, then blend this a little. Clean your hands, and sweep the sky colours over the distant crags on the left.

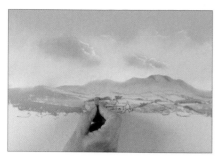

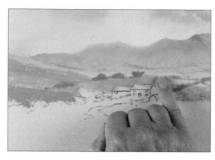

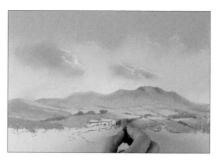

17. Add hedgerows further forwards with dark green-grey, pointing towards the farm. Suggest trees in some of the hedgerows.

18. Darken the field behind the farm with green-grey for contrast, suggesting a cloud shadow. Add a highlight with Naples yellow and soften this in.

19. Add more yellow ochre to strengthen the middle distance fields, then take the hedgerow up to the house with green-grey.

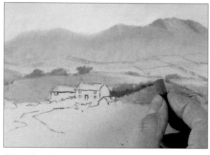

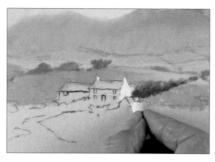

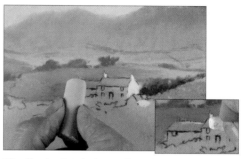

20. Use dark green-grey for the base of the hedgerow, and to contrast with the edge of the house.

21. Paint the highlighted right-hand sides of the house and the shed with white.

22. Shade the darker sides of the roofs with blue-grey, then add pale poppy red, suggesting a reflection of the sky. Use the white pastel horizontally to highlight the ridge lines of the roofs.

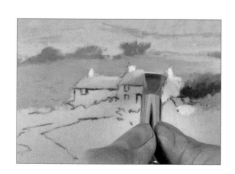

23. Use white again to highlight the chimney of the left-hand house, then use the size 6 colour shaper to blend the colours, dragging it downwards with the slope of the roofs.

24. Paint the front of the buildings and the chimneys with pale purple-grey.

25. Neaten the bright end of the right-hand house with a size 2 colour shaper, then use dark grey pastel pencil to darken the shaded sides of the chimneys, and add chimney pots with vertical strokes. Highlight the chimney pots with white pastel pencil.

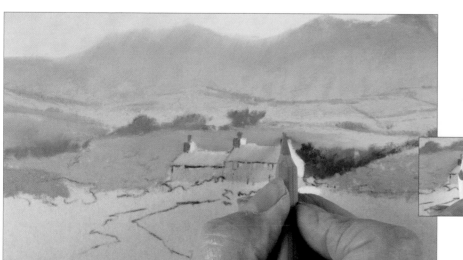

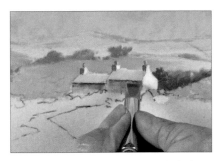

26. Shade under the eaves with dark purple-grey, then use the size 6 colour shaper to soften the edge of the shadow by dragging it downwards.

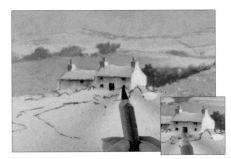

27. Use a needle-sharp charcoal pencil to draw in windows and a door, then use a grey pastel pencil to add a line down the left-hand side of the doorway, to recess the door.

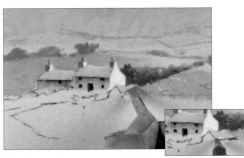

28. Paint the saggy roof of the little shed with pale blue-grey and a little white, then refine the shape with the colour shaper. Add a shadow under the eaves with grey pastel pencil.

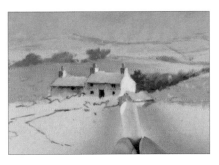

29. Use red-grey pastel to paint the end of the shed, then dot it with dark Naples yellow. Tidy with a colour shaper if necessary.

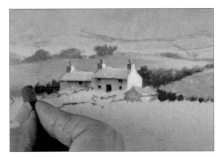

30. Add dark bushes behind the shed with dark purple-grey, using these to define its shape. Do the same for the left-hand house, adding dark foliage beside it and cutting back its shape.

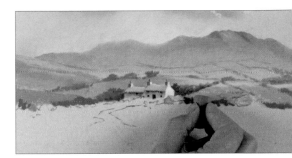

31. Continue the bushes outwards to make a long hedgerow with olive green.

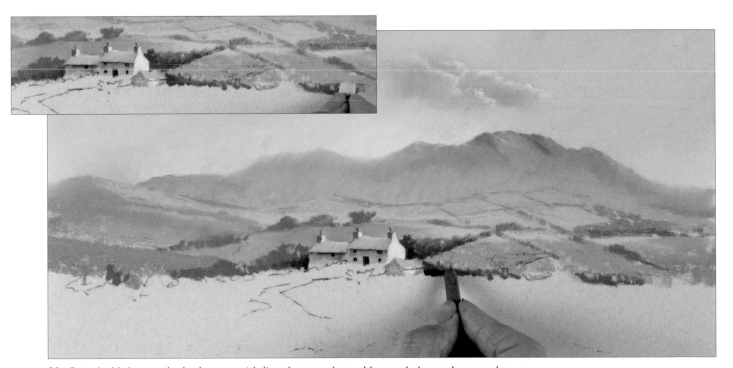

32. Paint highlights on the hedgerow with lizard green, then add very dark purple-grey close to the buildings to emphasise the focal point.

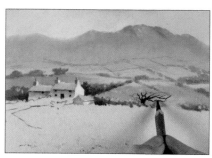

33. Use the charcoal pencil to draw the contorted branches of the tree in the hedgerow.

34. Dot in the leaves of the tree with dark purple-grey, then add further dots of olive green.

35. Darken the hedgerow under the tree with dark purple-grey. Add more olive green at the right-hand side.

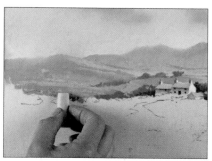

36. Highlight the ploughed field with pale poppy red.

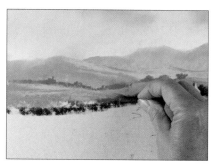

37. Paint a hedgerow at the back of the field with green-grey, then create the dark base of a hedgerow at the front with dark purple-grey.

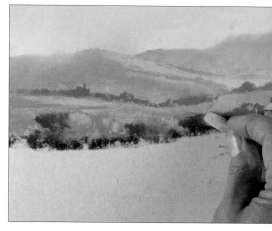

38. Create the foliage of the hedgerow with sap green for the mid-tones and dark green-grey for the shaded parts, then add highlights with lizard green.

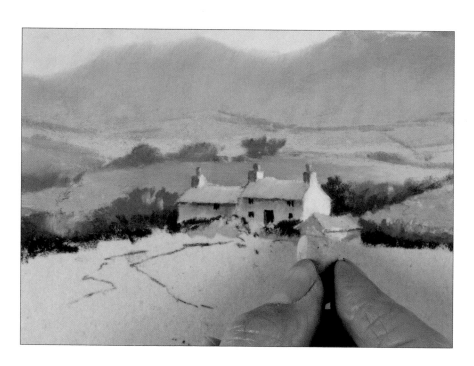

Tip

Allow the base of buildings to merge into the undergrowth so that they become part of the landscape. A straight line along the base of the wall makes the building look uncomfortable in its setting.

39. Use dark green-grey to create undergrowth to break up the baseline of the buildings, then add highlights with lizard green and yellow ochre.

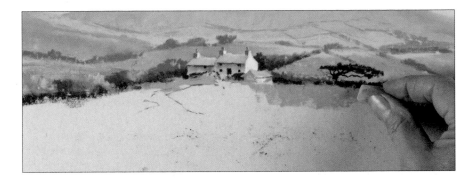

40. Continue painting the field edge with yellow ochre, adding vertical strokes into the bottom of the hedge to suggest grasses.

41. Paint pale burnt sienna in front of the yellow ochre, then burnt sienna for a medium-toned area in front of this, with vertical strokes suggesting growth.

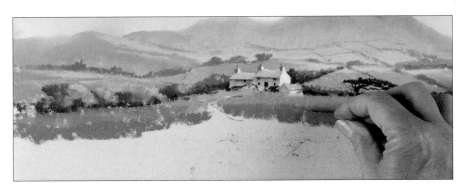

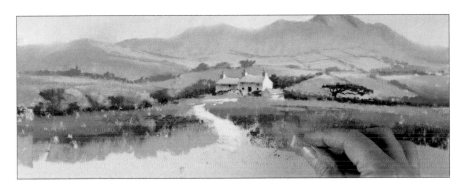

42. Use white to paint the track leading to the farm. Use dark grey to describe the rough ground coming towards the foreground, then yellow ochre further forwards.

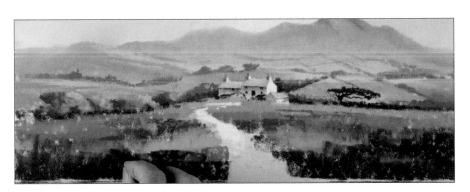

43. Vary the colour and tone of the foreground with dark burnt sienna, then burnt sienna, then paint dark purple-grey at the bottom of the painting.

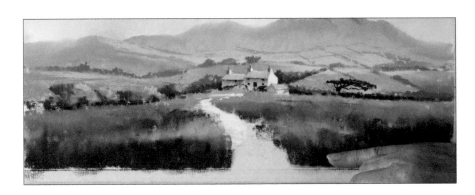

44. Blend some of the foreground, but leave other areas textured, suggesting rough ground. This way, you can get rid of any bits you don't like!

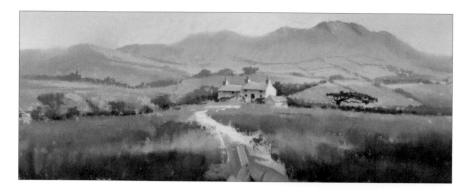

45. Darken the foreground of the path with purple-grey.

46. Add red-grey to vary the shaded area of the path.

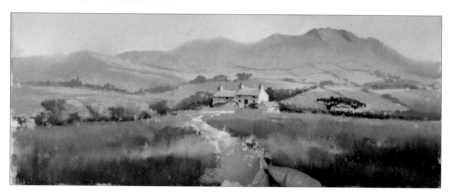

47. Dot in pale Naples yellow to suggest seed heads and flowers.

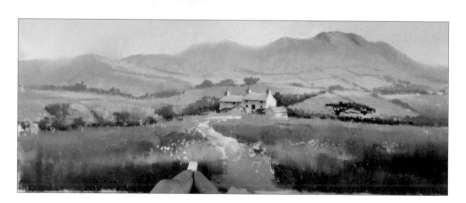

48. Further forwards, dot in larger white flowers to create linear perspective.

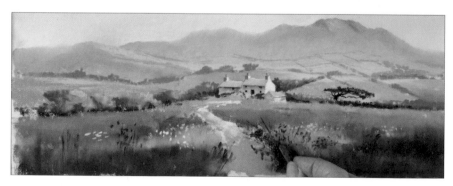

49. Use dark purple-grey to create seed heads in the foreground, suggesting that they are in cloud shadow. Paint stalks by pushing the whole length of the pastel into the paper to create a broken line.

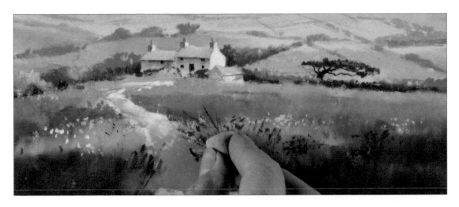

50. Add sap green behind the dark seed heads in places to vary the background, and soften it in.

51. Continue painting seed heads with dark purple-grey.

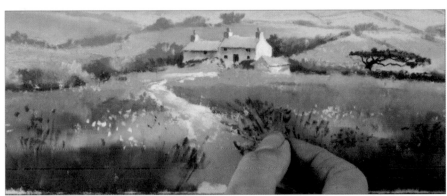

52. Shade the very front of the path with dark purple-grey, then add red-grey just above this and blend the two.

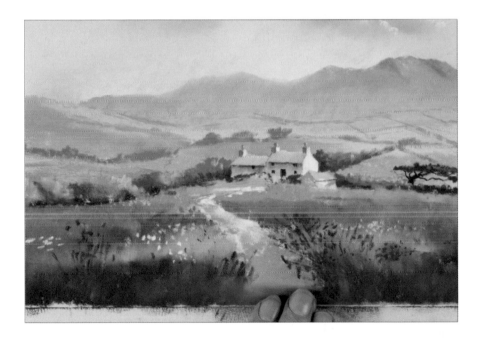

Tip
Use colour instead of detail in the foreground. Allow the viewer to use their imagination.

53. Finally add a few dots of colour here and there in the rough ground with yellow ochre.

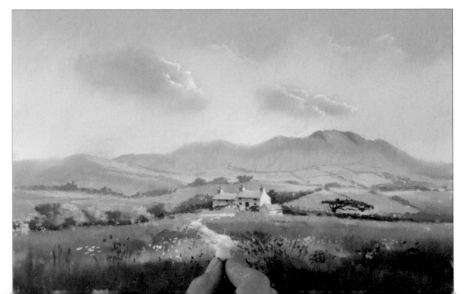

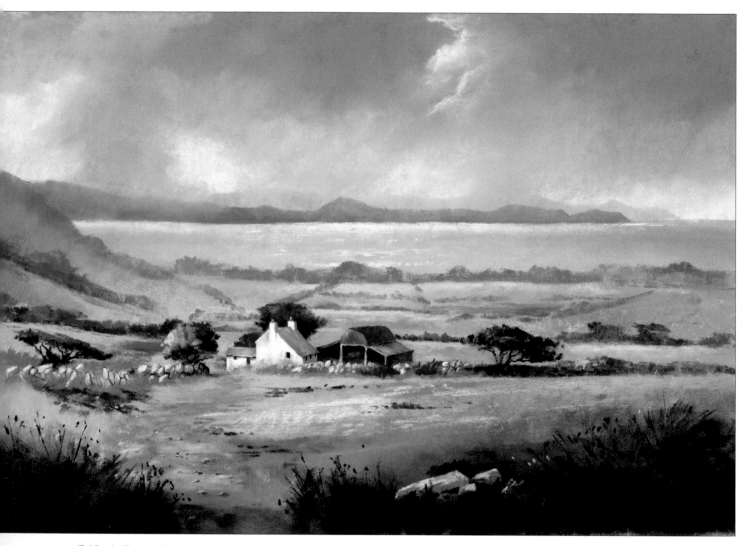

Gilfach Farm, Strumble Head

35 x 25cm (13¾ x 9¾in)

Looking out across Cardigan Bay from Strumble Head presents a panorama of some distance and with the addition of cloud cover, the atmosphere in this scene provides ample opportunity to portray aerial perspective. Notice how gradually the colours of the fields and trees change from cool to warm and light to dark as the eye travels down the painting.

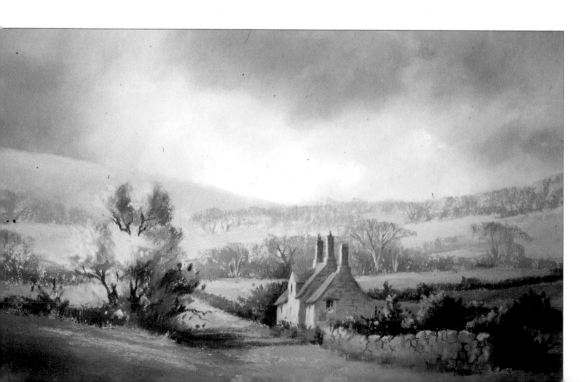

Cottage in the Cotswolds

27 x 16cm (10⅝ x 6¼in)

The distant trees are painted with the same colour and tone as the clouds; the trees in the middle distance have a little more colour, but it is not until you reach the focal point that the colour on the trees is warm. The mellow Cotswold stone in the cottage and the wall promotes a feeling of peace and tranquillity.

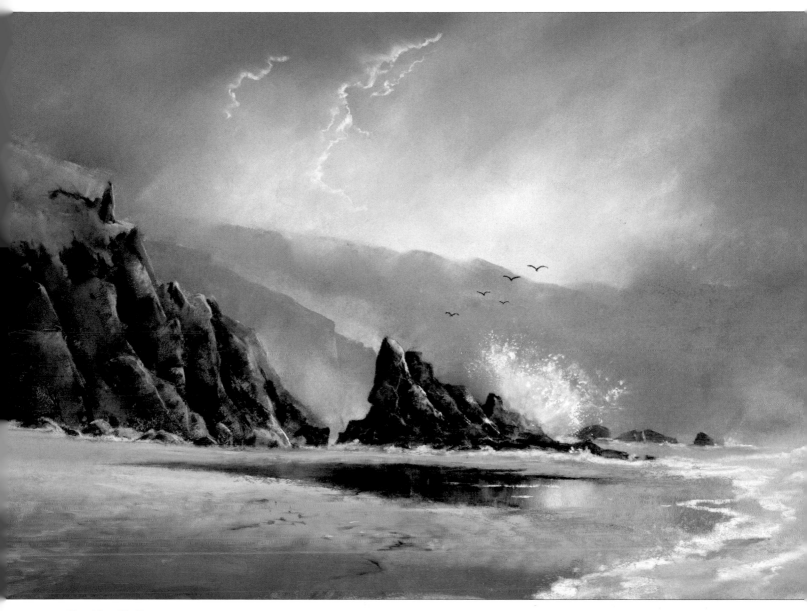

Barafundle Bay

33 x 23cm (13 x 9in)

There is a wide tonal variation between the distant coastline and the dark rocks on the beach which gives a strong impression of aerial perspective. The warm colour of the sand, together with the powerful tones in the reflection, keep the eye around the focal point. The breaking wave behind the rock was painted by gentle strokes of white followed by fine spray at the edges, which was created by the flaking technique: scraping flakes from the white pastel stick and pressing them into the surface with a palette knife. The birds were drawn in with a fine charcoal pencil.

INDEX

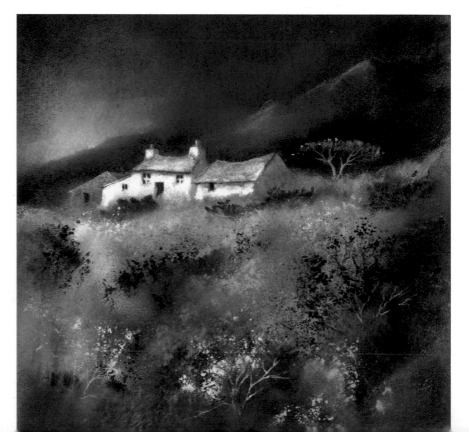

Farm in the Preseli Hills
20 x 20cm (7⁷/₈ x 7⁷/₈in)

You do not always have to paint daytime scenes. Moonlit landscapes can be mysterious and quite enchanting. At the full moon, there is often enough light to see clearly and if you stand long enough, your eyes adjust to the low light. You can also give free rein to your imagination.